Irene Cockroft

Irene Cockroft is an independent exhibit— —hor and lecturer specialising in the stor— the late 19th and early 20th century Ai— ements. Irene is the great-niece of suf— nestine Mills (1871-1959). She represe— omen's Suffrage campaign.

Her writing includes: *New Dau... ... — Women In The Arts & Crafts And Suffrage Movements At The Dawn Of The 20th Century;* Watts Gallery 2005.

Susan Croft

Dr Susan Croft has done extensive research and published widely on women playwrights. Her work includes: *Classic Plays by Women* (Aurora Metro 2010); *Votes for Women and other plays* (Aurora Metro 2009) and *She Also Wrote Plays* (Faber 2001). From 1997 to 2005 she was the Curator of Contemporary Performance at the Theatre Museum in London.

She co-directs the project *Unfinished Histories: Recording the History of the Alternative Theatre Movement* (see www.susan.croft.btinternet.co.uk and www.unfinishedhistories.com).

First published in UK in 2010 by

Aurora Metro Publications Ltd
67 Grove Avenue, Twickenham, TW1 4HX
www.aurorametro.com
info@aurorametro.com

We gratefully acknowledge financial assistance from The Heritage Lottery programme

With many thanks to Stacey Crawshaw, Rebecca Gillieron, Lesley Mackay, Pagan Hopkinson, Narinder Dosanjh, Neil Gregory, Sumedha Mane, Simon Smith, Sue Barber and the Museum of Richmond and all who have given permission for use of the images in this book.

Printed by Ashford Colour Press, Gosport, Hants.
Set in Georgia 10.5 /13 pt
ISBN 978-1-906582-081

LOTTERY FUNDED

ART, THEATRE
and
WOMEN'S SUFFRAGE

Irene Cockroft and Susan Croft

AURORA METRO PRESS

Special thanks to David Cockroft, Peter Beringer and Luke and Freya Croft Beringer for their patience and understanding during this project.

CONTENTS

INTRODUCTION

7. MUSIC

8. SPREADING THE WORD

~ INTRODUCTION ~

This short book has been written both as an outcome and accompaniment to the exhibition *How the Vote was Won: Art, Theatre and Women's Suffrage* at the Museum of Richmond, opening 1st May 2010, but it also stands on its own. It aims to offer an introduction to the general reader to the part that art and theatre played in the struggle for the vote for women and to give information about some of the key players who wrote, performed, directed, composed, designed, painted, made jewellery or otherwise made art in support of the cause of women's suffrage. To do this, it also tells the story of the main events and the central figures in the movement and outlines the positions taken by the organisations active within it, though it can only do this in general terms and directs the reader to other sources to discover the more detailed version. Ultimately, the book explores the position of women within the social and cultural context at the time and explains how the struggle for the vote grew to be such a dominant force.

The title of the exhibition is taken from the performance in February 1910 at Twickenham Town Hall of Cicely Hamilton and Christopher St John's famous comedy *How the Vote was Won*. A further aspect of both the exhibition and the book is to map something of the local impact of the suffrage movement within Richmond and some of its neighbouring boroughs. Where possible, examples of events are based on the locality, which fortunately in this context was one where there was lots of activity, from the suffragist rallies and meetings hosted by Lady Frances Balfour to the arson attacks by Kitty Marion and Lilian Lenton on Hurst Park Racecourse grandstand and Kew Gardens Tea House. There were many colourful characters with local associations like Princess Sophia Duleep Singh and Bertrand Russell, or down the road in Chiswick, Inez Bensusan.

The book and the exhibition reflect our particular areas of knowledge and passion as co-curators: art and theatre. We also attempt to trace the relationship of the suffrage movement to other art forms, like music, bringing together, we believe for the first time, a large collection of suffrage anthems.

The visual arts are in the fortunate position that they can be represented by a display of art objects and artefacts, many of which are reproduced here, but with theatre the art object itself is an ephemeral experience. Many of the productions documented here were one-offs or were performed at exhibitions, bazaars, fundraisers or rallies at a time when there was little theatre photography, so frequently all that remains is a programme or flyer, a review in the suffrage press and in some (not enough) fortunate cases a script. Some of these objects are on display in the exhibition but the reader is strongly encouraged to explore the various collections of Actresses' Franchise League and other suffrage scripts (such as *Votes for Women and other plays*). Reading them alone or in groups gives a truer sense of the humour, drama, pathos and sharp parody, and of the great diversity of work which was produced at the time from allegorical and symbolic ritual dramas to biting satire. While many are still to be rediscovered, some are already well-known, having proved their ability to hold an audience many times in regular revivals since the 1970s.

The book and the exhibition also examine the area where art and theatre meet, as identified by Lisa Tickner in her classic book *The Spectacle of Women: Imagery of the Suffrage Campaign 1907-1914* (1988). It looks at demonstrations that were costumed and choreographed for maximum effect – including the street parades led by 'Joan of Arc' and the funeral of Emily Wilding Davison – and also exhibitions which not only were the contexts for programmes of theatrical events but were carefully designed as stage sets for the enactment of the respectable demand for women's suffrage. Some of these, like the WSPU Women's Exhibition of 1909, referred also to the more controversial site of suffrage enactment, the prison, through their reconstruction of prison cells with former inmates playing the parts of prisoner and wardress. The performance of public protest, from public arrests to durational pickets was also aimed at targeting a wider audience, both directly and via the press and newsreels.

In the visual arts, the book addresses the work of women in the

ateliers, crafting banners, postcards, posters, and in the fine arts painting and enamelling. It also looks at the design of jewellery from campaigning badges to brooches, and at the medals presented to those suffering imprisonment for the suffrage cause. It looks briefly at individual dress and the struggle between conceptions of dress and womanhood. The *suffragist*'s garb made the statement that the vote was an adjunct to herself that did not challenge convention and femininity, while the practical and unencumbering wear of the *suffragette* bespoke equality and lent itself to a quick getaway. The book considers the symbolic role of clothing envisaged for the woman of the future, rejecting feminine frippery and narrow old-fashioned conceptions of a woman's role.

Finally, the book provides timelines of key events, highlights when and where women gained the vote and considers how later artists, playwrights, television producers and others have responded to the history of the suffrage movement. We hope that this book will provide the starting-points and the impetus for readers as well as visitors to the exhibition to further explore this fascinating history – local and national, social, political and cultural. For more information explore the website for the project www.suffragette.org.uk

Irene Cockroft and Susan Croft

1. ~ THE EARLY YEARS ~

The New Woman

In the last part of the 19th and the early 20th century there was an upsurge of questioning about what the 'proper' roles for women should be. Women began to gain access more widely to education at secondary level with the opening of girls' high schools. After long campaigns, women's colleges also began to be established including Cheltenham, Royal Holloway in Surrey, Westfield and Bedford Colleges in London, Somerville and Lady Margaret Hall at Oxford, Girton and later Newnham at Cambridge. Women began to gain access to professions previously closed to them, like medicine and the law. On the lower social rungs, women were working from an early age both inside and outside the house, in insanitary factories, as sweated labourers, as home workers. There was no birth control and families were large. Infant mortality rates were high and domestic violence rife. Newly educated and independent women increasingly started to use their voices to draw attention to these social problems.

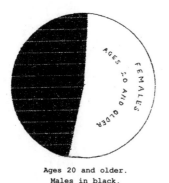

Ages 20 and older.
Males in black.

This diagram illustrates the numerical proportion of Females to Males in the population of the United Kingdom on April 6th 1895.

Contemporary *Strand* Magazine

A demographic 'surplus' of women in the population meant that fewer middle class women could expect to marry and be supported, forcing many to join their working class sisters on the labour market.

Young girls with typewriting skills working as clerks or secretaries began to appear in large numbers and in most cases were paid less than their male counterparts. Earning their own wage, more and more women were living outside the family home in rented rooms and shared flats.

New campaigns were initiated, protesting against unhealthy restrictive clothing such as the corsets and tight lacing which had physically restricted their foremothers and 'rational dress' became a trend. Women also began to participate in more sporting activities. The introduction of the bicycle brought women a new freedom of movement. A popular iconography of the New Woman began to emerge, using bold language, riding a bicycle, clutching her own latch-key and smoking a cigarette.

The increased freedoms and responsibilities made many women aware of their social and political position and of their exclusion from the democratic process and from the ability to change things through the ballot box.

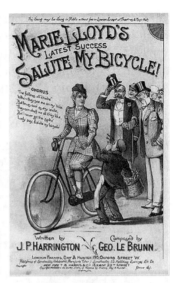

The woman cyclist is wearing 'bloomers', a form of rational dress; image courtesy of Theatrewords.

The Struggle for Women's Suffrage: the 1866 Petition

Spurred by life's inequalities, in 1866, artist Barbara Bodichon (1827-1891) proposed that members of the Kensington (Ladies' Debating) Society gather signatures, requesting votes for women. 1,499 courageous women signed. Elizabeth Garrett (later Doctor Elizabeth Garrett Anderson) and Emily Davies (later founding Principal of Girton College for Women) delivered the petition to Parliament.

They hid the cumbersome petition under an apple seller's stall in the lobby whilst they located John Stuart Mill (1806-1873). This newly elected Member of Parliament was sympathetic to the Women's Cause. In 1869, he was to publish a seminal work, *The Subjection of Women*. It had been written

The iconography of the 'new woman' in the poster for Sydney Grundy's play. Colour lithograph by Albert Morrow; image courtesy of Theatrewords.

jointly with his wife Harriet Taylor and was in the tradition of the great feminist treatises, *Vindication of the Rights of Women* by Mary Wollstonecraft (1792) and *Appeal of one half of the Human Race, Women, against the Pretensions of the other half, Men, to retain them in Political and Thence in Civil and Domestic Slavery* written by William Thompson and Anna Wheeler (1825). Mill presented the petition to the all-male House of Commons. The petition was greeted with derision.

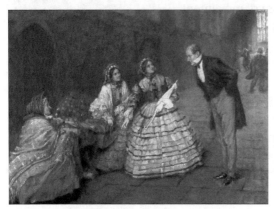

The Apple Seller by Bertha Newcombe;
image courtesy of The Women's Library, London
Metropolitan University.

In 1910, Bertha Newcombe (1857-1947), a member of the Artists' Suffrage League (ASL), commemorated the 1866 petition with her painting *The Apple Seller*. Women were no closer to being granted the vote.

After Parliament's rejection of the 1866 petition, forward-thinking women united to overcome male prejudice. Suffrage campaigning began. Denied university degrees and entry to numerous professions, many women honed their talents as artists, writers, actresses and musicians. These skills proved crucial in winning public acceptance of women's rights. The number of supporters grew.

Suffrage campaigners expressed their solidarity and determination to win equal voting rights with men by marching in processions carrying political banners they designed and made.

Suffrage contingents were formed from numerous sections of society including Catholic and Jewish women, in every major city and many towns throughout the country and involved working class women including factory girls as well as the middle and upper classes. Other groups represented women from within the professions open to women including doctors, teachers, typists, writers and artists. Each contingent added to the spectacle by adopting distinctive campaign colours. The Actresses' Franchise League chose pink and green.

The Cause behind the Campaign

In 1836, Caroline Norton (1808-1877) unsuccessfully opposed in court a vindictive husband who denied her access to their children. She lamented, 'I have no rights, only wrongs.'

The Women's Suffrage movement was driven by a deep and long-felt need for social reform among women and forward-thinking men. A male-dominated society was a biased society. Powerless women were treated unfairly.

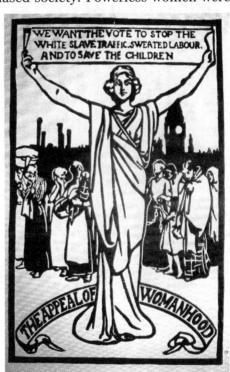

Designed by Louise Jacobs of the Suffrage Atelier, *The Vote* 6th July 1912.

Worldly interests, education, career and income were the prerogative of men. Women were expected to keep house, dependent on a husband, father or the next nearest male relative for their own keep. This could be a burden for men and degrading for women.

By the late 19th century, there was a surplus of females with no men to support them. The urgent need for females to learn and earn outside the home was largely ignored by an all-male government in which women had no say. Women's labour was exploited in the marketplace.

If a husband who was the tenant of a house died, his voteless widow and children could be evicted from their home. Ambitious landlords were only interested in male tenants who could vote them into Parliament. Women may have been taxed like men, yet they were denied a voice in how the money should be spent. Politicians looked after the interests of the voting man. The welfare of women and children was a low priority. Iniquities suffered by women and children were hidden within their domestic sphere.

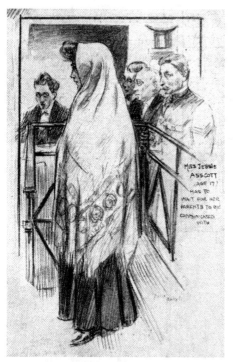

Miss Jessie Asscott aged seventeen was
arrested for taking part in an assembly of
women outside the Houses of Parliament.
Prisoner remanded in custody, no bail allowed.
Daily Graphic 22nd March 1907.

Having no other means of influence, women marched on Parliament to present petitions requesting the right to vote. They were treated as second class citizens, arrested and imprisoned under laws which they had no hand in making. No female lawyer was licensed to represent their interests in court. No females sat on juries.

Women wanted the vote to end discrimination and establish true democracy. The right to vote may be called suffrage, enfranchisement or emancipation.

2. ~ THE CAMPAIGN ~

The first organised campaigning for votes for women began in the 19th century after the Parliamentary Reform Act of 1832. Part of the general political struggle for reform and extension of the franchise to non-property-holding and working men, this had extended voting rights to half a million more men but denied voting rights to women.

Earlier, James Mill (1773-1836), Utilitarian, in his *The Essay on Government* (1820) had suggested:

'... all those individuals whose interests are indisputably included in those of other individuals may be struck off (the Electoral Register) without any inconvenience ... In this light women also may be regarded, the interests of almost all of whom are involved in that of their fathers or in that of their husbands.'

When the Parliamentary Reform Act was passed, it was found that the description of those entitled to vote had been changed from 'persons' to 'male persons' leaving women in no doubt that, although they were obliged to pay taxes like men, their views on how that money should be spent were disregarded. Low level political agitation simmered.

In 1867, the failure of a women's suffrage bill placed before Parliament by John Stuart Mill, son of James Mill, led to the formation of the National Society for Women's Suffrage in Manchester, gradually joined by numerous other branches around the country, which were united in 1897 in the National Union of Women's Suffrage Societies. The suffragists of the NUWSS were many more in number than the militants who in 1903 set up the Women's Social and Political Union (WSPU) and adopted direct militant action as tactics. By 1914, the NUWSS had 50,000 members, the WSPU 5,000. The suffragists of the NUWSS retained their focus on peaceful campaigning: petitioning, demonstrating, writing, speaking and teaching, organising and lobbying in favour of the vote.

In the early years of suffrage campaigning, many women paid allegiance to more than one suffrage society, believing a variety of approaches was necessary to achieve the joint aim. Camps polarised as the WSPU, which began by injecting new vigour into the campaign, became more autocratic, militant and seemingly counter-productive in its activities.

Many suffragists saw the violent tactics of the suffragettes as bringing the movement and the credibility of women as aspiring responsible members of political society into disrepute. It was felt that such tactics compromised the female values which they argued were needed in government and society and which necessitated that women should have a vote.

National Union of Women's Suffrage Societies

The statesman-like NUWSS relied on reasoned argument to bring about votes for women. The Union was led by Mrs (later Dame) Millicent Garrett Fawcett (1847-1929). Millicent was the youngest of a family of remarkable sisters from a politically enlightened and supportive home. Elder sister Elizabeth Garrett (Anderson) in 1865 became the first woman in England to become a licentiate of the Society of Apothecaries. This was followed by a string of 'firsts' including, in 1908, the first woman to be elected mayor (of her home town, Aldeburgh). Another sister, Agnes teamed up with her cousin Rhoda to found a successful architectural and interior design company.

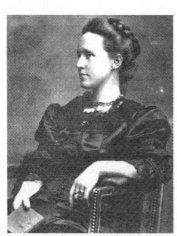

Millicent Fawcett; image courtesy of The Women's Library, London Metropolitan University.

In 1867, Millicent married MP Henry Fawcett who, although blinded in a shooting accident, was professor of political economy at Cambridge and a radical Liberal MP. Widowed in 1884, Millicent took up speaking engagements for the suffrage cause. Her assured platform manner and natural leadership ability quickly recommended her for higher office. In 1907, Millicent was elected president of the newly reorganised NUWSS. Her adaptable

mind, flair for neutrality and conciliation when political problems arose, good tactical sense and physical endurance served the countrywide Union of Suffrage Societies well, until her retirement in 1919. In 1918 she was elected a vice-president of the League of Nations. In 1925 Millicent Fawcett was created a Dame of the British Empire.

NUWSS campaign colours were red, white and green, the Italian national colours associated with the heroic Italian Risorgimento of the mid-19th century and General Garibaldi.

Women's Social and Political Union

Angered by the way in which Parliament ignored NUWSS initiatives, in 1903 Emmeline Pankhurst (1858-1928) founded the militant Women's Social & Political Union. Originally based in Manchester, its battle cries were 'Votes for Women' and 'Deeds not Words'.

Along with many of her followers, Mrs Pankhurst was imprisoned and went on hunger strike. She was released and re-arrested numerous times under a 'temporary discharge for ill-health' ('Cat and Mouse Act') provision.

WSPU members were described as 'suffragettes' by the *Daily Mail* newspaper to distinguish them in print from law-abiding 'suffragists'.

Although 'suffragette' originated as a term of mockery, it was proudly adopted by the militant branch of the women's movement. Emmeline Pankhurst and her daughter Christabel, frustrated at the failure of peaceable means, were anxious to distinguish themselves from the suffragists who remained wedded to non-violent tactics.

Further splits took place in the movement when Charlotte Despard formed the Women's Freedom League (WFL), breaking away from the WSPU which she found undemocratic in its focus on Christabel as a heroic and autocratic leader. Idolised by many WSPU members, Christabel believed in a disciplined organisation, following a strict party line.

In 1912, the Pethick-Lawrences, editors of the WSPU paper *Votes for Women*, were asked to leave the movement and in 1914 Sylvia Pankhurst was asked to create a separate organisation, as with her East London Federation of the WSPU she was taking a different line from that established by Emmeline and Christabel Pankhurst. Following in the

Labourite traditions of their father, the lawyer Dr Richard Pankhurst, Sylvia and Adela were socialists. They concentrated their efforts on organising working class women – in the East End of London in the case of Sylvia and in Yorkshire in the case of Adela.

In February 1914, Adela accepted a job offer from Vida Goldstein to help organise the militant Women's Political Association in Melbourne and emigrated to Australia, with the encouragement of her mother and Christabel.

Frustration in the movement at the government's prevaricating on votes for women led to policies advocating increasingly violent action directed against property. Women disrupted Parliament, chained themselves to railings, smashed windows, set fire to pillar boxes, burned down public buildings and the (unoccupied) homes of politicians. Suffragettes sought arrest and many went on hunger strike in prison to campaign against their classification as criminals rather than political prisoners. Such actions sought to dramatise and attract attention to the Cause where peaceful actions had been disregarded. The government response was also equally dramatic and aggressive, with the introduction of forced feeding for hunger strikers and of measures like the Cat and Mouse Act allowing re-arrest of those freed on health grounds.

Much of the written suffrage history has focused on the national movement, its leaders and activities such as demonstrations and window-breaking in central London. However, as writers like Jill Liddington have shown – see suffrage classic *One Hand Tied Behind Us* (1978), *The Long Road to Greenham* (1989) and her most recent suffrage history, *Rebel Girls: their fight for the vote* (2006) – there were highly active movements elsewhere in Britain, Scotland and many northern industrial cities. Often suffragettes were young and working class 'rebel girls', who risked losing their jobs and homes for the Cause.

Many young women including teachers became involved in the movement, taking direct action themselves or in support of others.

The Founding of the WSPU: Manchester 1903

'Mrs Pankhurst was now declaring that she had wasted her time in the I.L.P. She decided that the new organisation, which she would form without delay, should be called the Women's Labour Representation Committee; but when Christabel returned from a meeting with Miss

[Esther] Roper and Miss [Eva] Gore Booth and learnt the name her mother had chosen, she said it must be changed, for her friends had already adapted this title for the organisation they were forming amongst the women textile workers. Christabel did not at that time attach any importance to her mother's project; her interest lay with that of her friends. Mrs Pankhurst was disappointed and distressed that Christabel should insist upon their prior claim to the name she wanted, but she bowed to her decision and selected instead: "The Women's Social and Political Union".

Mrs Pankhurst; image from *Votes for Women* magazine supplement, October 1907.

On October 10th 1903, she called to her house at 62, Nelson Street a few of the women members of the I.L.P. and the Women's Social and Political Union was formed.

Katharine Bruce Glasier was then editing the *Labour Leader* in Black Friars Street, Manchester. I called at her office with a W.S.P.U. resolution for which publication was desired. She at once commenced to scold me for the aggressive attitude of our family, declaring that since her daughters had grown up, Mrs Pankhurst was no longer "sweet and gentle".'

from *The Suffragette Movement* by Sylvia Pankhurst

WSPU colours were 'green for hope, white for purity and purple for dignity'; sometimes interpreted as 'green, white, violet – give women votes.'

Women's Freedom League

From 1907, Mrs Charlotte Despard (1844-1939) led the breakaway WFL, founded after a group split from the WSPU. Its banner exhorted 'Dare to be Free'. The WFL approach to campaign planning was democratic. Not averse to civil disobedience, Mrs Despard followed the principle of 'passive resistance' advocated by Gandhi in India, rather than incite violent law-breaking.

From an Irish military family, Charlotte French married a wealthy radical liberal, Maximilian Despard. Widowed in 1890 she devoted herself to good works. This led to association with members of the WSPU, an organisation which she joined. Despard agreed with the objective, votes for women, but ultimately disagreed with WSPU despotism.

Like many suffrage campaigners of her era, Charlotte Despard was a vegetarian, Theosophist and devotee of the charismatic General Garibaldi, military leader of the nationalist Italian Risorgimento.

The WFL focused on a wider range of issues than just the vote itself including violence against women, women's exclusion from power, unequal pay and entrapment in narrow roles and expectations.

WFL members joined sub-groups like the Tax Resistance League and the 1911 census boycott.

The Actresses' Franchise League and the Writers' Suffrage League supported WFL events as well as WSPU and NUWSS events. WFL colours were green, white and gold reflecting hope, purity and WFL values.

Mrs Despard leading her followers in a parade; image courtesy of The Women's Library, London Metropolitan University.

3. ~ THE ANTIs ~

National League for Opposing Women's Suffrage

In 1910, the NLOWS was formed by amalgamating two smaller 'anti' groups. Its figurehead was prolific author of popular novels Mrs (Mary Augusta) Humphry Ward (1851-1920). Mary Augusta Arnold was born in Tasmania, Australia but her family returned to Britain when she was five years old.

She was born into an intellectual family of writers and educators, her grandfather being Thomas Arnold, the famous headmaster of Rugby School.

When not yet twenty-one years old, Mary married tutor, writer and editor Humphry Ward. She continued her studies, becoming a distinguished linguist.

Mary's rarefied background led her to believe that women had a distinctive role in doing good works and helping the disadvantaged, without the need to vote.

She helped establish an organisation for working and teaching among the London poor. This was originally called the Passmore Edwards Settlement, after its benefactor John Passmore Edwards. Now designated an adult education college, it is known as the Mary Ward Centre.

At first a cause for dismay among suffragists, NLOWS opposition proved a blessing in disguise. It exposed the feebleness of the argument against women's suffrage. Mrs Humphry Ward's own achievements were proof that the exclusion of such women from the ballot box was a serious loss to the country.

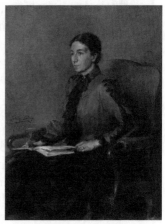

Mary Augusta Ward by Julian Russell Story, 1889; image courtesy of the National Portrait Gallery.

In the 'comedietta' by Beatrice Harraden, *Lady Geraldine's Speech*, a suffragette describes herself as tired but proud, having sold all her *Votes for Women* magazines. She proclaims:

> 'One man bought six copies. He said he had been an Anti until yesterday, when he went to an Anti meeting and that converted him!'

The Arguments Against

Women and men opposed the suffrage movement for a variety of reasons and by various means. Numerous opinion polls throughout the suffrage campaign continued to find the majority of women not wanting a vote.

Some women's commitment to this belief led to their active involvement in anti-suffrage campaigning. Others, however, were hampered by their very belief that the sphere of appropriate activity for women could not directly involve them in a political campaign. These women had to remain relatively passive in support of their cause.

Anti-suffrage metal badge in black and orangey-red; image courtesy of V. Irene Cockroft, photo David Cockroft.

'Antis' tended to believe that a woman's role should concentrate on womanly duty, a maternal position and the exercise of influence and reform through other means – through the example of her behaviour, service and gentle influence on men for the good. Prominent anti-suffragist writers included the novelist Ouida and the traveller and diplomatist Gertrude Bell. Even women committed to the extension of women's rights in other areas were included in the 'Antis' group, such as Elizabeth Wordsworth, principal of Lady Margaret Hall, the Oxford women's college and also Florence Bell, playwright and friend and collaborator with suffragist and social campaigner Elizabeth Robins. Often anti-suffrage campaigners combined an involvement in social action with their anti-suffrage views, their actions based on a belief in women's distinctive role in doing good works and helping the disadvantaged.

Despite this reluctance to involve themselves in politics the anti-suffragists did become organised.

Key dates include:

1889
~ Launch of the 'Appeal Against Female Suffrage' with 104 signatories, led by Mary Ward, which when published in the 19th century gathered 2,000 more signatures to 'Female Suffrage: A Women's Protest'.

1908
~ Launch of the Women's National Anti-Suffrage League. Over the next ten years, establishment of over 100 branches.

1910
~ Merger with the Men's League for Opposing Women's Suffrage.

The movement launched the *Anti-Suffrage Review* which denounced the suffragettes for their unfemininity, violence, sexual deviance, hysteria, unnaturalness, claiming their behaviour was a threat to the women they represented as it exposed them to ridicule and insult. (See *Women Against the Vote: Female Anti-Suffragism in Britain* by Julia Bush (2008)).

The contradictions of the anti-suffrage argument become the grounds of comedy in pro-suffrage writing. Many Actresses' Franchise League sketches and short plays feature anti-suffragists such as Cicely Hamilton and Chris St John's *The Pot and the Kettle*, where an anti-suffrage supporter is mortified to find herself under arrest when her anti-suffrage passions drive her to attack a suffragette. Other examples include *A Chat with Mrs Chicky* by Evelyn Glover, in which Mrs Holbrook is bested by the charwoman she tries to convert to the anti-suffrage cause, or *Lady Geraldine's Speech* by Beatrice Harraden, a play which portrays an anti-suffragist turning to an old friend in composing a speech who is gradually converted by her and her intelligent women friends to pro-suffragism.

4. ~ ART FOR VOTES' SAKE ~

When a late 19th century census confirmed over a million surplus women with no men to support them, government action included opening schools of art to women. Sylvia Pankhurst, Ernestine Mills and Olive Hockin were among thousands who grasped the opportunity to learn and earn.

In rural areas without access to formal training, often women were taught arts and crafts skills by other women who might also market the wares produced, establishing a combine. The harsh reality was that few women managed to forge a fine art career in the male-dominated marketplace. This meant that a pool of fine artistic talent was subverted to the arts and crafts advocated by William Morris. Training in art reproduction methods, and in craft skills such as embroidery and stained glass heraldic design, proved as valuable as fine art training to the first generation of significant numbers of women to have access to a vocation. Arts and crafts became valuable tools in the weaponry of the Votes for Women campaign.

Artists' Suffrage League members were professional artists prepared to contribute time and talent to the Cause. There were such artists in many parts of the United Kingdom. The Glasgow Girls, who trained at the Glasgow School of Art under Francis Newberry and his embroideress wife Jessie, were remarkable for style, energy and commitment to the Women's Cause. The ASL campaign colours were blue and silver.

Professional artists at the Suffrage Atelier trained amateurs to produce simple but effective political propaganda, mainly for the WSPU. Atelier campaign colours were blue, orange and black.

ANNIE SWYNNERTON (1844-1933)

Among the first wave of suffrage artists, Swynnerton stands out as

remarkable for her talent and determination to overcome discrimination against women. The first woman to be elected to the Royal Academy since the 18th century, Annie Swynnerton paved the way for younger artists. A portrait by Swynnerton of NUWSS leader Dame Millicent Fawcett in an academic gown is in the Tate collection. Also at Tate Britain is *New Risen Hope* painted by Annie in 1904. It depicts a mystical girl child emerging from watery depths at daybreak, an analogy with the hoped-for dawn of women's rights. Annie's London studio was in the Fulham Road.

SYLVIA PANKHURST (1882-1960)

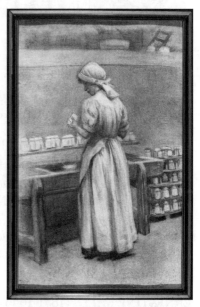

The artist most associated with the women's suffrage campaign is Sylvia Pankhurst. Whilst her older sister Christabel trained in law, Sylvia's talent won her a scholarship to the Royal College of Art.

When her mother, Emmeline, founded the Women's Social and Political Union, Sylvia became official artist. Her mural decoration for the fundraising Women's Exhibition of 1909 held at the Prince's Skating Rink in Knightsbridge, London, was a triumph.

Sylvia set herself the task of travelling the country painting the poor industrial conditions under which many women worked.

Pottery worker by Sylvia Pankhurst, 1907; image courtesy of Richard Pankhurst OBE, photo David Cockroft.

As a suffrage campaigner, Sylvia was imprisoned thirteen times, went on hunger strike and was forcibly fed.

Sylvia's father, socialist lawyer Dr Richard Pankhurst, died when she was sixteen. Socialism later drew her to London's impoverished East End where the vote would help working women. Sylvia founded the East London Federation of Suffragettes (ELFS) with campaign colours purple, white, green and red.

Sylvia's trumpeting angel design, used on the cover of bound copies of *Votes for Women;* image © Richard Pankhurst OBE, photo David Cockroft.

On the outbreak of WWI, men were conscripted. Factories closed. Sylvia wrote of the women and children left behind, 'I saw starvation look at me from patient eyes. I knew then that I should never return to my art.' Sylvia, a pacifist, directed her energy into organising local self-help establishments.

Socialism and pacifism placed Sylvia at odds with her mother Emmeline as well as her older sister Christabel who based hope for the success of the suffrage campaign on the social influence of middle and upper class women.

In 1914, Sylvia was expelled from the WSPU.

Sylvia continued challenging the world's wrongs by founding a socialist newspaper, *The Workers' Dreadnought* which she edited for ten years. When Italian Fascist dictator Mussolini invaded Ethiopia in 1936 she focused the world's attention on the outrage by publishing another paper, *New Times and Ethiopia News*. Her agitation helped stir allies into action to assist Ethiopia regain independence.

ERNESTINE MILLS (1871-1959)

Tina studied fine art at the Slade School of Art and enamel-on-metal skills at Finsbury Technical College. Combined art and craft skills enabled her to create jewellery in suffrage campaign colours. Apart from her commercial output, Mills crafted suffrage jewellery to be presented as rewards for valour and to sell at bazaars to raise funds.

She also enamelled an enduring legacy of consciousness-raising and commemorative plaques for the Cause. Mills was commissioned by the Suffragette Fellowship to enamel a memorial plaque for the Brackenbury family who hid suffragettes sought by police for re-arrest under the

terms of the Cat and Mouse Act. The Brackenbury Tablet is conserved at the Museum of London.

London-based suffrage artists tended to work out of studios in Kensington, Chelsea, Hammersmith and Fulham. The childhood home of Ernestine Mills for a time was Barnes, later Kensington – which remained her home for life. Her studio there was a converted stable at the end of the garden, directly opposite the exotic home and studio of Royal Academy President, Lord Leighton.

Mills exhibited at the Royal Academy, Arts & Crafts Exhibition Society, Walker Gallery and Society of Women Artists of which she was treasurer. From 1940 she served on the council of the Central Institute of Art and Design.

Emmeline and her husband were Fabians. Dr Herbert Henry Mills was physician to The Lady Frances Balfour, the Pankhurst family and the Zangwill family. An advocate of affordable health care for the poor, Dr Mills served on the Advisory Committee when the Lloyd George National Health Insurance Act was formulated in 1911. Their daughter Dr Hermia Mills (1902-1987) studied psychology under Carl Jung. During her career she served as medical officer at Holloway Prison.

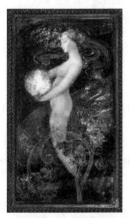
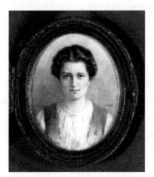
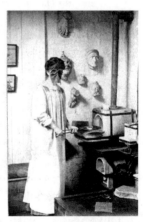

The little mermaid braved the dangers of the deep to secure the priceless pearl of suffrage. Enamel by Ernestine Mills c.1918; image © V. Irene Oockroft, photo David Cockroft.	Miniature portrait of Ernestine Mills in blue painting smock by Edith Hinchley; image courtesy of V. Irene Cockroft, photo David Cockroft.	Ernestine Mills enamelling in her Kensington studio; image courtesy of V. Irene Cockroft.

D.G. Rossetti's poem *The Blessed Damozel* was illustrated by Olive Hockin
in 1909. Olive draws on the imagery of suffragettes embroidering banners for
her vision of a sisterhood stitching heavenly raiment.Watercolour 51 x 61cm;
image courtesy of the family of Olive Hockin and
V. Irene Cockroft, photo David Cockroft.

OLIVE HOCKIN (1881-1936)

A theosophist, Olive studied at the Slade. Her work was exhibited at the
Royal Academy and the Walker Gallery. Hockin painted heroic-scale
watercolours at her Notting Hill studio and when police raided it in
March 1913 they found wire-cutters, hammers, false car licence plates,
fire-lighters and bottles of corrosive fluid. The press described it as 'a
suffragette arsenal'.

Olive was imprisoned that year for her suspected part in an arson
attack on Roehampton Golf Club and for involvement in causing
damage to the Orchid House at Kew Gardens. A Holloway Prison
surveillance photograph shows Olive wearing a black armband, almost
certainly a sign of mourning for the death, whilst Olive was in prison,

of Emily Wilding Davison after being trampled by horses' hooves at the Epsom Derby.

Olive served as a Land Girl during World War I. She wrote a book on her experiences, *Two Girls on the Land: War-time on a Dartmoor Farm,* published by Edward Arnold, London in 1918.

EDITH HINCHLEY (1870 - ?)

Portrait miniaturist Edith Hinchley, close friend of Ernestine Mills, wrote in *The Vote* magazine of 12th August 1911:

'The swift response of the woman artist to the Women's Movement is no mystery. The difficulties placed in women's professional path make them feminists. Equal citizenship is a starting point to redressing the degradation of inferior status.'

This talented artist perished when her Earls Court flat was demolished in the World War II bombing blitz on London.

MAY MORRIS (1862-1938)

May, daughter of designer William Morris, became the first president of the Women's Guild of Art. The Women's Guild was founded in 1907 to counter-balance the exclusively male Art Workers' Guild. An authority on embroidery, May designed the Fabian Women's Group banner (now lost) for the suffrage processions of 1908. May designed textiles and wallpapers for Morris and Co, some designs like 'Honeysuckle' proving perennially popular for stylish house furnishing. She also designed jewellery. Bead necklaces were a speciality.

After her father's death May Morris took on the Herculean task of editing his writings. They were published in twenty-four volumes between 1910 and 1914.

EMILY FORD (1850-1930)

Based in Chelsea, the London studio of the Artists' Suffrage League

vice-chairman was a haven for political activists. Emily, a staunch suffragist from Leeds, was a landscape and figure painter who exhibited at the Royal Academy and Society of Women Artists. Like so many members of the Artists' Suffrage League, she trained at the progressive, unisex Slade School of Art which opened in 1871. Here young women who previously would have grown to adulthood in domestic isolation tutored by a governess, tasted the joy and power of networking and bonding with their peers.

Emily was a member of the Ladies' National Association for the Repeal of the Contagious Diseases Acts. Social reformer Josephine Butler was a family friend. There is a 1903 signed photolithograph by Emily Ford of Josephine Butler in the Special Collections at Leeds University Library. One of her five sisters, Isabella Ford also became well-known as a socialist, feminist campaigner and novelist. Emily wrote several one-act plays with feminist content including *Rejected Addresses* and *Careers*, and performed monologues called *Character Sketches from Yorkshire Life*, to suffrage audiences. She chaired outdoor suffrage meetings and was adept at dealing with rowdy audiences.

CLEMENCE HOUSMAN (1861-1955)

Clemence and her brother Laurence Housman were prominent members of the Suffrage Atelier, which was based at their Kensington studio. The poet A.E. Housman was the third member of three talented siblings. Clemence and Laurence wholeheartedly supported the women's suffrage campaign.

Laurence designed the *From Prison to Citizenship* banner for the Kensington WSPU to brandish aloft in the Women's Sunday procession to Hyde Park in June 1908.

Clemence was one of the finest wood engravers of her time. She was also a skilled needlewoman and according to her brother was 'chief banner maker' for the Suffrage Atelier. Clemence was a founder member and committee member of the Women's Tax Resistance League. In 1911, she served a prison sentence for non-payment of tax.

At the Atelier, professional artists trained amateurs to produce simple but effective political propaganda, mainly for the WSPU. Atelier campaign colours were blue, orange and black.

A PATRIOT (ALFRED PEARSE) (1856-1933)

Alfred Pearse was a regular cartoonist for *Votes for Women* from the issue of 18th February 1909, signing his work 'A Patriot'. He also designed a number of the most effective WSPU posters and may have been the anonymous creator of the powerful Cat and Mouse Act image of a ferocious cat sinking its teeth into a dangling suffragette.

Pearse was best known as a black and white artist, wood engraver, book and periodical illustrator. He was employed by the *Illustrated London News, Strand Magazine, Cassell's Family Magazine* and *Punch*. His political work for the WSPU deserves wider recognition.

Flying Colours: Suffrage Banners

MARY LOWNDES (1857-1929)

Stained glass artist Mary Lowndes, partner in the firm of Lowndes and Drury, was chair of the Artists' Suffrage League. ASL members were professional artists prepared to contribute time and talent to the Cause. Drawing on her stained glass heraldic training, Mary designed most of the NUWSS banners carried in processions. She trained at the Slade and privately under arts and crafts designer Henry Holiday, who with his wife and daughter had long been a supporter of women's suffrage.

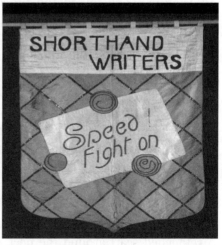

Mary Lowndes' album of designs is preserved at The Women's Library, London Metropolitan University. In spite of suffering from asthma, Mary was one of the hardest working suffrage artists, exhibiting at the Royal Academy, Society of Women Artists, Manchester Art Gallery and the Walker Art Gallery.

Design for Shorthand Writers' banner from album of Mary Lowndes, Artists' Suffrage League; image courtesy of The Women's Library, London Metropolitan University.

In her instructions to women designing and making suffrage banners Mary explained:

'A banner is not a literary affair ... A banner is a thing to float in the wind, to flicker in the breeze, to flirt its colours for your pleasure, to half show and half conceal a device you long to unravel.'

Photographers

LENA CONNELL (1875-1949)

We owe a debt to a group of female photographers such as Lena Connell, Mrs Albert Broom, Annie Bell, Marie Leon and Yevonde Middleton, for recording images of suffrage leaders, campaigners and activities. Photographic portraits of Emmeline and Christabel Pankhurst and Actresses' Franchise League theatrical personalities might be sold as postcards to raise funds for the campaign, or published as publicity for the Cause.

Lena Connell followed her father's profession as a photographer, from her teens. She won the gold medal of the Professional Photographers' Association. Lena joined the processions of the WSPU, the London Society for Women's Suffrage and the Artists' Suffrage League. She photographed Mrs Pankhurst and many other leading members of the suffrage campaign, either on active duty or more formally in her studio at St John's Wood.

A list of 'Photographs and Photographers' may be found in *The Women's Suffrage Movement, a Reference Guide 1866-1928* by Elizabeth Crawford (1999). Elizabeth Crawford makes the point that two types of photograph are often extant of suffragettes who served prison sentences; a privately arranged, well lit studio portrait intended for family and friends and a prison surveillance snapshot intended for opponents of women's suffrage.

Police surveillance photographs show dishevelled women under duress. A retouched scarf around the neck was a useful device for masking the manhandling of victims into position. Sheets of such photographs were circulated to help those in authority, such as curators of art galleries, to recognise the women after they had been released from custody.

The women were thus identified as threats to both the peace and to property.

For identification purposes, the studio portrait might have been more useful. On the other hand, the police snapshots show a more human and heroic side to the subjects that family and friends might treasure more than a studio-posed likeness.

The Anti-League in Art

Suffrage artists and anti-suffrage artists vied with one another in a propaganda war. Around 1912, Harold Bird for the National League for Opposing Women's Suffrage produced an Anti 'Appeal of Womanhood' poster depicting a 'womanly woman' displaying a 'No Votes Thank You' sign whilst an angular harridan runs around with a 'Votes' flag.

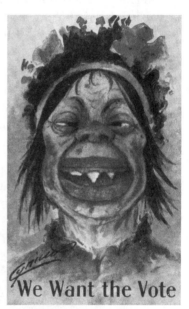

In direct response, Louise Jacobs of the Suffrage Atelier produced a pro-suffrage poster where the womanly woman displays the sign, 'We want the vote to stop the white slave traffic, sweated labour, and to save the children,' thus wrong-footing the NLOWS.

Many anti-league members, like Liberal activist and public servant Violet Markham (1872-1959), later changed their minds about opposing women's suffrage.

Anti-suffrage postcard; image courtesy of the Museum of London, photo David Cockroft.

In her autobiography *Return Passage* (1953) Markham wrote:

'I came slowly but surely to change my mind and to change it so fundamentally that I find it difficult now in retrospect to give a very coherent account of what took me originally into the other camp ... Why was I converted (to being pro-women's suffrage)?

Partly because I had come to see that Lincoln's principle "a country cannot be part serf and part free" applied to the relations of men and women as well as to those of black and white: partly because I had gained a great deal more experience of women's work and of the disabilities under which women often labour. I had become conscious that in spite of any affection and regard for many of my anti-suffrage friends, the denial of political rights to women involved a spiritual as well as a political principle. It meant, in effect, the stabilisation of a status of permanent inferiority. I did not think women were going to regenerate the world, far from it; nor that the glowing promises of the suffragists would be fulfilled. But without this reform, social and political life would rest on a basis chronically lopsided and unfairly weighted against one sex.'

Perhaps this summing up of a convert explains why surviving NLOWS badges are rare. Did women want to pass on to their children evidence that they once wore a badge proclaiming they believed their sex too stupid to vote?

Anti-suffrage posters and postcards caricatured women who wanted the vote, as undesirable, thus fusing gender fears with political orientation. But where was the intellectual argument?

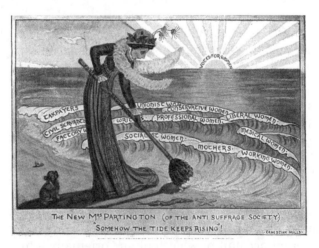

Ernestine Mills pro-suffrage postcard *The New Mrs Partingdon*;
image © V. Irene Cockroft, photo David Cockroft.

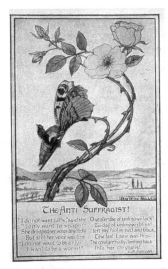

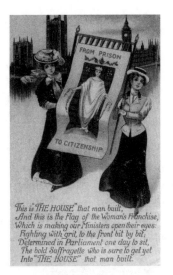

Ernestine Mills pro-suffrage postcard
The Anti-Suffragist; image © V. Irene
Cockroft, photo David Cockroft.

Pro-suffrage postcard design by Laurence
Housman; image courtesy of V. Irene
Cockroft, photo David Cockroft.

Ernestine Mills self-published two postcards attacking the anti-suffragists, *The New Mrs Partington* (an old-fashioned lampoon character, see opposite) and *The Anti Suffragist* with verse by American activist Charlotte Perkins Gilman.

The artist behind the 'House that Man Built' series of pro-suffrage postcards and small posters produced by a commercial postcard publisher remains anonymous. The pro-suffrage postcard picture above features the *From Prison to Citizenship* banner designed by Laurence Housman for the Kensington WSPU. An anti-suffrage series on the same theme soon followed. The postcard manufacturer won either way.

5. ~ PERFORMING WOMEN'S SUFFRAGE ~

Spectacle and performance were central to the campaign for women's suffrage in both its peaceful and militant branches. It was the first large-scale movement to use the resources of photography, cheap illustrated newspapers and early newsreels to publicise its cause. For the militants, the image of the woman chained to the railings or carried off by the police was designed to shock an audience of readers and viewers and galvanise their support.

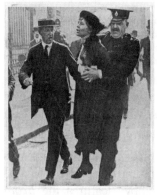

Emmeline Pankhurst is arrested at a protest outside Buckingham Palace; image courtesy of the Mary Evans Picture Library.

Both the law-abiding suffragists and the militant suffragettes staged regular large-scale demonstrations between 1907 and 1913.

Women taking to the streets broke the taboos that still confined them to the domestic sphere, displayed the sheer numbers supporting the Cause and contradicted popular anti-suffrage imagery that represented them as harridans and shrews.

Suffrage demonstrations were carefully choreographed events, reflecting the contemporary popularity of pageants. They drew on the organisational and artistic expertise of skilled theatre professionals, such as Edith Craig and Sime Seruya, to create demonstrations with maximum public impact. Women were often dressed in white, with purple, white and green sashes. They marched under embroidered banners, with drum and fife bands, in groups from all over the country.

This emphasised the geographical breadth of support with branches represented from Margate to Inverness. Highly qualified female teachers and doctors drew attention to the fact that despite their professional achievements and their status as tax-paying citizens, they were still denied the vote.

In organising suffrage fundraisers and other events, as well as providing theatrical entertainments, women drew on performance skills in campaigning and raising awareness. Even long-term protests, like the 540 hour WFL picket that Alice Chapin pays tribute to in her play *At the Gates*, were conceived effectively as durational performances, designed for an audience, enacting women's patient endurance and fortitude through adversity.

The Women's Exhibition at Prince's Skating Rink in 1909 featured a reconstruction to its exact size, of a 2nd division cell where visitors could experience the conditions undergone by women prisoners and contrast them to those of the neighbouring 1st division cell as assigned to male political prisoners in Ireland, which were double the size, furnished as they chose and where they could wear their own clothes. Former suffragette prisoners played themselves, undertaking the duties required in prison and other volunteers played warders, allowing visitors to experience something of the claustrophobic conditions of the jail for themselves.

Revolting Women – the Monstrous Regiments

Women had little means of public influence other than in their own persons – and society decreed that those persons be largely confined to the home. In the first decade of the 20th century, a company of women walking the street was, in itself, sufficiently shocking to draw a crowd. It also drew newspaper coverage and attracted converts to the Women's Cause.

In publicising their political message women exposed themselves to verbal abuse and physical attack. With no alternative, women marched for the right to vote as the first step towards a more equitable society. Suffrage parades became a regular city spectacle.

1907

~ The first suffrage parade was the NUWSS's bedraggled, wet February traipse of 3,000 Constitutionalists through London city streets, led by Millicent Fawcett, Lady Frances Balfour and Lady Strachey. Impressed by the women's valiant efforts to demonstrate solidarity and numbers, the march received a sympathetic press. It entered history as 'The Mud March'.

1908

~ The success of 1907 led to an NUWSS march through London on 13th June 1908, for which the Artists' Suffrage League designed and made banners. It was supported by similar events held by local societies throughout the country.

~ This was followed by the spectacular WSPU 'Women's Sunday' rally at Hyde Park on 21st June, a masterpiece of organisation which was famously advertised to the House of Commons by Flora Drummond. 'General' Drummond hired a boat with a suffrage team and with the banner 'Cabinet Ministers Specially Invited' and a loud hailer assailed Parliament from its vulnerable river side. River police soon caught up with them.

Advertised as a monster meeting, the *Daily Chronicle* assessed the crowd in the park as surpassing 300,000 people of all classes.

1909

~ The build-up to the WSPU Women's Exhibition in Knightsbridge in May 1909 began with an Easter parade led by 'Joan of Arc'.

Joan of Arc

In April 1909, after being ignored for five centuries, Joan of Arc, The Maid of Orleans, was beatified by the Church of Rome as a first step towards sainthood.

The Maid had long been taken to the heart of suffrage campaigners. They regarded Joan as their patron saint well in advance of the formal declaration of sainthood that came in 1920. Barbara Forbes of the ASL had designed a Joan of Arc banner in 1908 (now in The Women's Library collection) that was carried by the NUWSS in its street parade demonstration of June 1908.

It was fortuitous that the sanctification coincided with the year of the fundraising Women's Exhibition organised by the WSPU at the Princes' Skating Rink, Knightsbridge.

A street parade took place through London's West End, led by Elsie Howey riding a white horse. Elsie represented Joan of Arc, dressed in armour and carrying a purple, white and green oriflamme. It was a popular reminder of women's courage in a good cause.

Joan of Arc again took to the streets in the women's cause in the Women's Coronation Procession of 1911, played by Marjorie Annan Bryce.

Joan at the head of the procession inspired art-enameller Ernestine Mills to create an enamelled plaque. Due to the permanence of colour, enamel on metal has been the traditional medium of commemoration for noble persons and deeds.

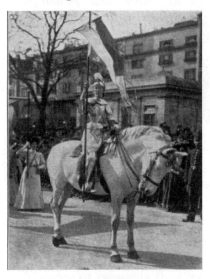

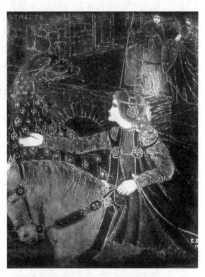

The noble image of Elsie Howey mounted on a palfrey was reprinted in *Votes for Women,* April 23rd 1909, p574; image courtesy of Half Tones.

Joan of Arc enamel by Ernestine Mills; image © V. Irene Cockroft, photo David Cockroft.

1910

~ Despite back room dissension, the NUWSS and WSPU cooperated in staging a 'From Prison to Citizenship' procession on 23rd July 1910. It lent support to the voters' Conciliation Bill before Parliament. Hopes of 'Votes for Women' were high. Spectator hostility was changing to good humoured acceptance and even encouragement.

When the bill was shelved, angry women converged on the House of Commons, to be met by unprecedented police brutality. Many women were badly injured in the government-condoned violence against them. November 18th 1910 entered the annals of women's suffrage history as 'Black Friday'.

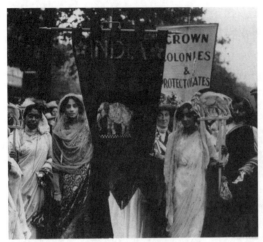

Indian suffragists in saris taking part in the Women's Coronation Procession in June 1911; image courtesy of the Museum of London.

1911

~ One of the most joyous spectacles was the Women's Coronation Procession of June 1911, celebrating the accession of King George V. All three main women's unions participated. There were around 40,000 women, representing at least twenty-eight suffrage organisations, who marched with a thousand banners. There were many overseas contingents. The procession was seven miles long.

1913

~ Funeral

The saddest spectacle for many was the funeral procession of Emily Wilding Davison. To generate publicity for Votes for Women, Davison

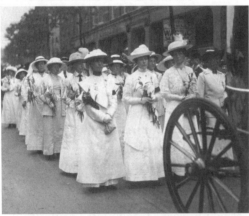

The funeral procession of Emily Wilding Davison, trampled beneath the hooves of the King's horse at the Derby, 14th June 1913; image courtesy of the Mary Evans Picture Library.

had attempted to attach a WSPU pennant to the King's horse, Anmer, running in the Derby at Epsom on 4th June. She was fatally injured by horses' hooves and died in hospital on 8th June without regaining consciousness.

On the 14th June 1913, Emily was accorded a martyr's funeral service at St George's, Bloomsbury. Afterwards, the funeral cortege travelled from Charing Cross railway

station to the Davison family grave in the village of Morpeth, Northumberland. The routes in London and Morpeth were lined with thousands of mourners. The funeral arrangements, made by Grace Roe, involved the participation of the WSPU, Women's Freedom League, New Constitutional Society, Women Writers' League, Church League for Women's Suffrage and the Actresses' Franchise League.

~ Pilgrimage

On 18th June, the NUWSS pilgrimage began. Societies from all parts of England, travelling by every convenient method, formed into ranks outside London and marched to converge in Hyde Park on 26th July where speakers addressed the throng. On 8th August, Prime Minster Asquith received a deputation of leaders of the Pilgrimage, the first deputation he had agreed to see since November 1911. The Pilgrimage was a moral victory for the women but brought no change in government policy.

1915

~ The most heroic demonstration was the 'Women's Right to Serve' War Work procession of July 1915 in which women demanded the right to serve their country as land girls and in dangerous occupations like munitions workers, in spite of still being denied the vote. The day proved a wet one.

Beleaguered Belgium, in the Pageant of the Allies section, was represented by a young woman dressed in purple and black. Battered but unbroken, Belgium strode barefoot through the day's mud, brandishing her tattered flag aloft against driving rain – the epitome of British womanhood, empathising with the small country overrun by its expansionist neighbour in all-out war; an apt analogy perhaps, with the plight of women.

6. ~ ACTING UP!
THE ACTRESSES' FRANCHISE LEAGUE ~

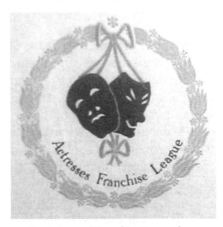

The Actresses' Franchise League logo;
image courtesy of Theatrewords.

Prologue

'Before the sunrise there must come the grey,
So bear with me – the prologue to the play.
Not mere diversion is our true intent,
To whisper it – on politics we're bent.
While preachers rarely to performance reach,
We at one blow shall both perform and preach.
You dreamed us dummies to fit dresses on,
To prop heroic mask of Amazon,
Not so; behind our mask we keep our soul,
Nor take our mimic world for the great whole.
All noble causes tax our pence and prayers.
Are all the men and women merely players,
As Shakespeare said? Then players in their turn

Are men and women who aspire and yearn.
And is it true that all the world's a stage?
Then we would act on that and on the age.
And so we covet parts in that great play
For which the whole world is a stage to-day;
That draw with a purpose finely human,
To raise man higher by uplifting woman.
The scoff, the blow, the prison – worst of all,
The bitter need like men to bawl and brawl.
And wherefore, prithee, all this monstrous ransom?
How is she not man's equal, save more handsome?
In Shakespeare's day, if Clio's voice be truth's,
His heroines were played by beardless youths.
Just fancy Rosalind a real role,
Quaffing between the acts her stoup of ale,
Or Perdita concealing manly art,
Or Desdemona shaving for the part.
Imagine some mere man for Ellen Terry –
You might as well replace champagne by sherry.
We've won equality upon the boards,

But on the world's stage men are still the lords,
Making sad mischief with their stupid swords.
The time is out of joint – let's set it right,
Not whine and wail with Hamlet 'cursed spite'
Ah, if instead of suicide suggestion
To vote or not to vote had been the question
Ophelia had met, with mocking flout,
Hamlet's male insolence of sneer and doubt.
Nunnery forsooth! When she at Hamlet's fat form
Could thunder suffrage from the castle-platform!
'The time is out of joint' Then what's the cure?
Joint work of men and women to be sure.
Joint work to foster every noble growth,
Joint work to make a better world for both.
Then have at you, my lords, on with the fray.
How long, o lords? Till woman has her way.'

Israel Zangwill

'We the undersigned, members of the Actresses' Franchise League, beg to address you as follows. While adding to the gaiety of the nation the actresses have themselves been suffering from great wrongs arising out of sex disability. The broad expansive view of life that the actresses' calling engenders has revealed to them the state of society in Great Britain which they, as patriotic women, can no longer support. Debarred by sex ability from the exercise of the franchise to right these wrongs, repudiated by the government of the day, unprotected by party machinery, the actresses, representing a very large and important faction of working women, do appeal to the House of Commons, and ask to be allowed to stand before the bar of the House and lay before the Commons at first hand their reasons for claiming equality with men in the state. This meeting of actresses calls upon the Government immediately to extend the franchise to women: that all women claim the franchise as a necessary protection for workers under modern industrial conditions, and maintain that by their labour they have earned the right to this defence.'

<div align="right">Gertrude Elliott</div>

The Actresses' Franchise League or AFL was formed in 1908 when an inaugural meeting was held at the Criterion Restaurant in Piccadilly. Well-known actresses like Ellen Terry, Madge Kendal and Lena Ashwell, along with hundreds of rank and file actresses, pledged their support to the cause of women's suffrage. They ranged from established performers like Lillah McCarthy, Irene and Violet Vanbrugh and Gertrude Elliott to young up-and-coming actresses such as Athene Seyler and Sybil Thorndike. The League pledged to support the Cause through:

I) Propaganda Meetings
II) Sale of Literature
III) Propaganda Plays
IV) Lectures.

They also aimed 'To assist all other Leagues wherever possible'. In setting out their aims they stated that only actresses were to be eligible for the Executive Committee, though membership was open to all those currently, or formerly, connected with any branch of the theatrical profession, on payment of one shilling and that the AFL were 'strictly

neutral in regard to Suffrage Tactics'. There were later disputes about this. Within the League there were those who supported the WSPU and spoke out for (and engaged in) militant activity and others who saw this as tarnishing their professional image.

Over the next six years, in collaboration with the Women Writers' Suffrage League, the AFL was responsible for the writing and production of suffrage plays at numerous events from meetings in East End settlements and Girls' Clubs to suffrage bazaars. But their activities also included training fellow suffragists in public speaking, hosting debates, opening fundraising galas, organising AFL members on tour in the regions to provide entertainment for local suffrage groups and even using their make-up skills to help disguise suffragettes on the run from the police.

The work of the AFL also fed into the foundation of a number of other groups dedicated to using theatre to support the suffrage cause and wider feminist issues. In some cases, like the Pioneer Players, their work moved into introducing innovative new plays and experimenting with new forms.

The final tableau, probably in its Cardiff production, of the hugely popular play *How the Vote was Won* by Cicely Hamilton and Christopher St John. In it women, denied a vote, go on strike and ask to be supported by their nearest male relative until the horrified men get up in arms and march in support of women's suffrage. It was staged at Twickenham Town Hall in 1910; image courtesy of The Women's Library, London Metropolitan University.

'My first experience of the Actresses' Franchise League as a body corporate was in the Criterion [at Piccadilly Circus] last spring. I had been asked by it to speak at one of the "At Homes"; and I spoke with diffidence. It is somewhat of a trial for an amateur-outsider to practice before trained elocutionists; but my audience – eager, sympathetic, ready and able to give full value for every attempted inflection of voice, even for every hesitation in thought hampered by words soon made me feel, even while I spoke, that here, if anywhere, I had struck on something different from the ordinary male world, something apart from the commonplace conventional male estimate of things – on the something, briefly, which it is the aim and object of our Feminist movement to restore to its proper place in the equation of life. Quick intuitions, ready emotions, aye! Even hasty generalisations must have their value to humanity; since they *are*. And I felt, also, that surely here, amongst these women, banded together to enforce their equal right with men to the parliamentary vote, though many of them might be militants, and all were ready to face male condemnation for their opinions, there could yet be found every cherished attribute of the male conception of womanhood at its best.'

from 'An Outside Impression of the Actresses' Franchise League' by Flora Annie Steel, author of *Tales of the Punjab, English Fairy Tales,* & c. (Originally published in the *Souvenir of the Women's Theatre Inaugural Week*, Coronet Theatre, Notting Hill Gate, London, 8th to 13th December 1913, p21 and 22.)

Actresses, Writers and Stage Designers

INEZ BENSUSAN (1871-1967)

Inez Bensusan was born in Australia where women gained the vote in 1902. In Britain, she rapidly became actively involved in running the AFL Play Department. In her own moving play *The Apple*, the daughters are neglected in favour of the son, the apple of father's eye.

Bensusan went on to set up the Women's Theatre season at the Coronet Theatre in 1913.

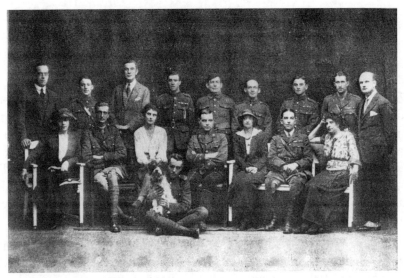

Bensusan with the British Rhine Army Dramatic Company for whom she wrote, directed and performed c.1919; image courtesy of Lawrence Duttson.

With the outbreak of war, like many in the suffrage movement, she switched her energies into war work, a means of proving women's equal citizenship. The Women's Theatre performed extensively for troops in France and Bensusan then worked with the British Rhine Army Dramatic Company. In later years, she settled in Chiswick, co-founding the House of Arts to encourage theatre, art and music locally. She died in 1967 aged 96.

ELLEN TERRY (1847-1928)

Ellen Terry was the most famous actress of her day and a founder member of the AFL, lending the authority of her name and standing to highlight the absurdity of women's disenfranchisement. In 1909, when the AFL staged the first production of *A Pageant of Great Women* as a fundraiser and support for the Cause, she played actress Nance Oldfield:

'By your leave, Nance Oldfield does her talking for herself!
If you, Sir Prejudice had had your way,
There would be never an actress on the boards.
Some lanky, squeaky boy would play my parts:

And though I say it, there'd have been a loss!
The stage would be as dull as now 'tis merry –
No Oldfield, Woffington – or Ellen Terry!

Ellen Terry was the third of eleven children of actors Ben and Sarah Terry and followed her parents and sister Kate into acting. She received no formal education but made her stage debut at the age of nine playing Mamillius in Shakespeare's *Winter's Tale*. In 1864, aged sixteen, she modelled for and married the painter George Frederick Watts, many years her senior. The marriage lasted only ten months. Then Terry returned to the stage but left again when she met the designer and architect Edward Godwin, who was the father of her children Edward Gordon and Edith Craig.

Returning to the stage after six years, she established herself as Britain's leading Shakespearean actress and in 1878, formed a partnership with Henry Irving at the Lyceum, where he became actor-manager, playing numerous leading roles opposite him. They dominated English theatre for over twenty years. In later years, she moved to Smallhythe, Kent. Her last stage appearance was in 1925, the year she was made a Dame of the British Empire (DBE). She also appeared in films and toured the USA as a lecturer and recitalist.

Ellen Terry as Imogen in Shakespeare's *Cymbeline*; image courtesy of the Mary Evans Picture Library.

Ellen Terry's home at Smallhythe in Kent, now owned by the National Trust; photo Susan Croft.

CICELY HAMILTON (1862-1952)

Cicely Hamilton was one of the most prolific and successful of the suffrage playwrights. Her 1908 play, *Diana of Dobson's*, staged by Lena Ashwell at the Little Theatre, dealt, like her book *Marriage as Trade*, with the economic options open to women. She jointly wrote *How the Vote was Won* with Christopher St John. It was staged by suffrage groups all over Britain and in the USA. Hamilton also spoke at rallies and published widely on suffrage topics. *The Sergeant of Hussars*, was produced by the Play Actors in 1907, in a double-bill with Rose Mathews's *The Parasites* in aid of the Actors' Association. Other plays for the suffrage cause included the celebrated *A Pageant of Women* (Scala, 1909) and *The Pot and the Kettle* (with Christopher St John, 1909). Her play *Jack and Jill and a Friend* was staged by the Pioneer Players in 1911.

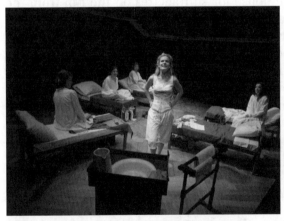

Diana of Dobson's produced at the Orange Tree Theatre, Richmond in 2007, photo Robert Day.

Cicely Hamilton from the programme for the Women's Theatre season, Coronet Theatre, 1913; image courtesy of Theatrewords.

EDITH CRAIG (1869-1947)

Edith Craig, known as Edy, was the daughter of Ellen Terry and architect William Godwin and sister of stage designer and theorist Edward Gordon Craig. She began her career as a stage manager and a costume designer. In 1899, she met Christopher St John (Christabel Marshall) and they set up house together in Smith Square, becoming active members of the suffrage movement, artistic collaborators and lovers.

Edith Craig began establishing a career as a director, buying the rights to suffrage plays, directing numerous AFL productions including *How the Vote was Won* and numerous versions of Cicely Hamilton's *A Pageant of Great Women* around the country. With Chris, she went on to set up the innovative theatre company The Pioneer Players, producing numerous plays by women and introducing new European theatre work.

George Bernard Shaw observed that Edward Gordon Craig had become world famous by virtue of producing very few plays while his sister was virtually unknown but had produced everything. In the 1920s, she went on to work at the Everyman Theatre, Hampstead and as Art Director of the Leeds Art Theatre. With Chris, she set up home at Smallhythe in Kent, in a house next to her mother's, later in a *ménage-à-trois* with the artist Claire Atwood. Their home at Smallhythe became a safe-house for suffragettes on the run from the police. In 1928, she converted the adjoining barn into a theatre where annual Shakespeare productions have since been staged in memory of Ellen Terry as well as other performances. Craig is said to have inspired the character Miss LaTrobe in Virginia Woolf's *Between the Acts* (1941) who directs a village play about the history of England. Her work has gained increasing critical recognition in recent years.

Edith Craig; image courtesy of The Women's Library.

The Priest's House, home of Edy Craig, Christopher St John and Claire Atwood at Smallhythe (now owned by the National Trust); photo V. Irene Cockroft.

CHRISTOPHER ST JOHN (1871-1960)

Christopher St John assumed the name when she converted to Catholicism. She was born Christabel Marshall, daughter of a banker and the novelist, Emma Marshall. Chris went to Oxford University and then worked as Secretary to Lady Randolph Churchill. In 1899, she fulfilled a long-standing desire to meet Ellen Terry and met and fell in love with Terry's daughter, Edith (Edy) Craig.

Chris remained devoted to Edy throughout her life, supporting her in her directing career: St John's 1915 novel, *Hungerheart: The Story of a Soul* (1915) is a fictionalised version of their relationship. With Edy, she established the innovative Pioneer Players, which produced many of Chris's plays along with many other feminist writers and experimental works from the European repertoire, many of them translated by Chris. Chris St John also edited *Ellen Terry's Memoirs*, wrote music and dramatic criticism, in particular for *Time and Tide* and *The Lady*, and a biography of composer and feminist, Ethel Smyth.

ELIZABETH ROBINS (1862-1952)

Born in Kentucky, Elizabeth Robins moved to London in 1889 and soon established a reputation as a major actress, best-known for performing in and producing Ibsen's plays. She published the first of her fifteen novels in 1892 and co-wrote the controversial play on infanticide *Alan's Wife* with Florence Bell (produced anonymously).

Her play *Votes for Women* appeared at the Royal Court in 1907 and in novel form as *The Convert*. She became the first President of the Women Writers' Suffrage League and later published her writings and speeches on the suffrage movement in *Way Stations*.

Elizabeth Robins in *Hedda Gabler*
image courtesy of the Mark Samuels Lasner Collection, on loan to the University of Delaware Library.

PAMELA COLMAN SMITH (1878-1951)

Pamela Colman Smith was the daughter of an American father and a Jamaican mother. 'Pixie' Colman Smith was an artist, theatre designer and close friend of the household at Smallhythe. With W.B. Yeats and Florence

Farr, she was a member of the Golden Dawn movement, who saw social and spiritual transformation as intrinsically linked. She produced the illustrations for Ellen Terry's book *The Russian Ballet* and designed for the Pioneer Players. Colman Smith contributed to the lampoon *An Anti-Suffrage Alphabet* compiled by Laurence Housman.

She contributed designs to the Suffrage Atelier and worked for various suffrage-orientated theatre companies. She also published several volumes of Jamaican folktales. The tarot-cards she designed, known as the Rider-Waite deck have become the world's bestselling pack.

Designed by Pamela Colman Smith; image courtesy of the Mark Samuels Lasner Collection, on loan to the University of Delaware Library.

Other Feminist Theatres

The plays staged by the AFL were part of a proliferation of plays by women at the time, many of them dealing with women's lives and contemporary social issues. In Manchester, Annie Horniman, an heir to the Horniman tea family fortune, set up the Gaiety Theatre. Along with the celebrated names of the Manchester School playwrights like Stanley Houghton, Harold Brighouse and Allen Monkhouse, Horniman staged both AFL plays like Barrie's *The Twelve Pound Look*, P.R. Bennett's *Mary Edwards* 'an anachronism' and Shaw's *Press Cuttings* and many other plays by and about women by authors including Laurence Alma-Tadema, Elizabeth Baker, Edith Ellis, Margaret Mack, 'George Paston', Gertrude Robins and Antonia

Williams. Many of these writers were also active in the suffrage cause.

In London in 1904, Edith Lyttelton's play *Warp and Woof* was a success at the Camden and later the Vaudeville Theatre, produced by Mrs Patrick Campbell who took the main role as Theodosia Heming. It examined the plight of underpaid seamstresses, working through the night in West End sweatshops to make ball gowns for upper class women with lives very different from their own. Its author later became a vice president of both the Conservative and Unionist Women's Franchise Association and of the London Society for Women's Suffrage.

In 1914, Mrs Alexander Gross's *Break the Walls Down*, at the Savoy Theatre, was dismissed by mainstream critics as Suffragette nonsense but was favourably reviewed in *Votes for Women* and *The Vote on* 22nd May 1914. Gross's daughter was Phyllis Pearsall, the mapmaker responsible for the *London A-Z*.

The Pioneer Players were founded by Edith Craig and Christopher St John. The Pioneer Players grew out of their many productions for the suffrage movement. Their first productions were 'propaganda plays', chiefly those dealing with the woman's movement, as that is at present the most important'. These included Chris St John's *The First Actress,* Charlotte Perkins Gilman's *Three Women*, Kate Harvey's *Baby*, Jenny (Mrs Herbert) Cohen's *The Level Crossing*, Laurence Housman's *Pains and Penalties* and Margaret Wynne Nevinson's *In the Workhouse*. They went on to present numerous European plays in translation (usually translated by Christopher St John herself) including the first English version and production of *Paphnutius* by Hrotsvitha of Gandersheim, who was the first woman playwright, as well as plays by Herman Heijermans, Paul Claudel, Nikolai Evreinov and Anton Chekhov. A theatre club, often performing on Sunday afternoons, their work was not subject to the Lord Chamberlain's censorship, though when they tried to put on controversial works like a non-subscription performance of Chris St John's and Charles Thursby's *The Coronation*, this was banned. The company also introduced the work of numerous women playwrights, presenting the first British production of Susan Glaspell's *Trifles* and plays by Antonia Williams, Gwen John, Delphine Grey (Lady Margaret Sackville) and Gabrielle Enthoven.

The Play Actors were founded by Rose Mathews as an outlet for performers active in the recently-formed Actors' Association, the forerunner of Actors' Equity. Other prominent AFL activists within the Actors' Association included Winfred Mayo and Sime Seruya, joint founders of the AFL, Italia Conti (founder of the Italia Conti stage school), A.M. Heathcote and Cicely Hamilton. There was a close relationship between women's activism in the Union and suffrage activism, despite, or because of, the Association's exclusion of women from its ruling council. The Play Actors produced programmes of new plays on Sundays which were often experimental or dealing with social issues. They also organised fundraising and campaigning events. Mathews' play *The Parasites* aimed to draw attention to the 'steamy side of stage life' and the exploitation of actresses by unscrupulous agents and their exclusion from roles by well-heeled amateur actresses who paid for the privilege of appearing on stage and took work from the professionals. Mathews played artist Angelica Kauffman in the first production of the AFL's *A Pageant of Great Women,* and her one-act play *The Smack* opened a Laurence Housman double-bill at a matinee for the Suffrage Atelier, on 27th May 1910. Its cast included Decima Moore.

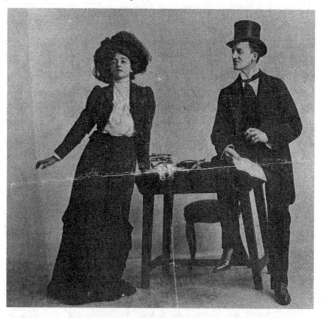

Mathews in the lead role of her own play *The Parasites* (1907);
image courtesy of Theatrewords.

The Propaganda Players

There were many other companies set up to do new plays and to support the suffrage cause, sometimes one-offs, sometimes more consistently. *The Vote* of 20th January 1912 announced the formation of The Propaganda Players:

'Branch secretaries will be interested to hear that the Propaganda Players, who have been in active rehearsal for the last few weeks, are now ready to book engagements for the rest of the winter season. They will perform Suffrage plays and plays dealing with the Woman Question for any Branch without fee provided such Branch will pay all out-of-pocket expenses, and, if necessary, provide the players with hospitality, all profits resulting from the entertainment to be retained by the Branch. There are vacancies in the company for two gentlemen and the hon. Secretary will be glad to hear from experienced amateurs.

The Propaganda Players hope to supply a felt want and to be of great assistance to the Branches. There is no doubt that strong Suffrage play is excellent propaganda and the players have the sole acting rights of some very good plays. For all particulars apply to Mrs E.P. Fielden, "Lynton", Dormers Wells, Southall, Middlesex.'

Among their members were Isabel Tippett (1880-1969), a cousin of Charlotte Despard and member of the WFL. Her play *The Stuff That 'Eroes Are Made Of*, was first performed at the International Suffrage Fair, Chelsea Town Hall in November 1912 and then by The Propaganda Players. The author was mother of composer Sir Michael Tippett and an ardent suffragist, imprisoned for her activism. It was directed by Winifred St Clair, herself the author of several suffrage plays.

Performances at WSPU's Women's Suffrage Exhibition, Princes' Skating Rink, Knightsbridge for 13th-26th May 1909

The programme for this Exhibition gives a useful example of the range of performances provided by the AFL. This fortnight-long event included an extensive array of stalls selling everything from farm and garden produce to

craft items made by WSPU members, from bookstalls selling suffrage literature to hats donated by Liberty and Derry and Toms, palmistry, a bandstand, an ice cream soda fountain and a polling booth where women could experience how votes were cast.

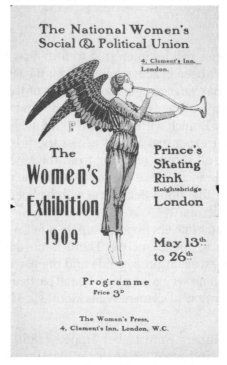

Exhibition programme designed by Sylvia Pankhurst; image courtesy of the Museum of London.

There were five entertainments daily, provided by the AFL. Entertainments varied daily but the programme included:

'A Suffrage Episode by Rita Milman
Meringues: a Drawing Room Duologue by Mabel Annie St Clair Stobart
A Woman's Influence by Gertrude Jennings
How the Vote was Won by Cicely Hamilton and Christopher St John
The Philosopher in the Apple Orchard by Anthony Hope
Duologues performed by Eva Moore and Henry Ainley

Colonel and Mrs Henderson by Rosina Filippi
Kiddy by Cyril Twyford, with Suzanne Sheldon and
Henry Ainley
A suffragette opera
Murder – a tragedy
A Gertrude Jennings play arranged by Beatrice Forbes
Robertson (May 13th)
A variety entertainment by Miss Esmé Hubbard and Mr Horace
Beaumont including ten minutes of condensed Grand Uproar,
entitled La Suffragetta (May 15th)
Dreams by Olive Schreiner, performed by Miss Sydney Keith
A White Carnation by Justin Huntly McCarthy with Mrs and
Mrs Benjamin Webster (May 20th)
Love in a Railway Train with Gillian Scaife and Ashley
Pearson (May 24th)
A play by Miss Beatrice Forbes Robertson (May 26th)'.
Thus It Was by Rita Milman (May 26)

Performances at National WSPU's Christmas Fair and Festival, 1911

Entertainments included:

'Mon 4th Dec, in the Theatre
Entertainments:
3.45pm - Musical
4.30pm - *The Twelve Pound Look* by J.M.Barrie
6.00pm - Dramatic and musical entertainment –
 Miss Nellie Sargent
8.30pm - Music
9.15pm - *An Allegory* by Vera Wentworth. Produced by
Frederick Morena

 Cast Woman – Miss Maud Hoffman
 Fear – Beatrice Filmer
 Prejudice – Mr Frederick Morena
 Slave Woman – Violet Bazalgette
 Courage – William Stack
 Man – Lancelot Lowther

Dec 5th included *Miss Appleyard's Awakening* by Evelyn Glover
The Maid and the Magistrate by Graham Moffatt
The Apple by Inez Bensusan with Auriol Lee and Winifred
Mayo

Wed Dec 6th *Trimmings* by M. Slieve McGowan. Produced by
Madeleine Lucette Ryley
Thurs Dec 7th *Before Sunrise* by Bessie Hatton. Cast included
Cicely Hamilton
Fri Dec 8th *Physical Force* by Cecil Armstrong and Mrs Garrud
(a ju-jitsu play)
Sat Dec 9th *The Woman with the Pack* by Gertrude Vaughan'

A special section 'The Fun of the Fair' was organised by the Men's
Political Union for Women's Enfranchisement:

'No village fair was ever complete without the playful and
amusing Punch and Judy, hence the Men's Political Union
will entertain the visitors by several suffrage dialogues from
the orchestral platform in the large hall. These plays have
been specially written by Miss Inez Bensusan and others.

Mr Herbert Collings presents *Drawing Room Seance* and
conjuring entertainment.'

Other Players

Besides those individuals whose stories are given briefly elsewhere in
this book, many others contributed to theatre for the Cause, through the
AFL, WWSL or otherwise. Here are some of them:

LAURENCE ALMA-TADEMA (1865-1940) lived at Wittersham, the friend
and neighbour of the Smallhythe household in Kent, she was the daughter of
artist Sir Lawrence Alma-Tadema and poet, playwright and translator and
editor of the periodical *The Herb o' Grace*. Her plays are symbolist works,
reflecting contemporary interest in the mystical worlds and theosophy. At
least one was produced by Annie Horniman at the Gaiety Theatre.

LENA ASHWELL (1872-1957) well-known actress and director, she managed the Savoy Theatre and later ran the Kingsway Theatre. She also founded the Three Arts Club to provide good quality accommodation for women in the arts. Later, with AFL colleagues Eva and Decima Moore, she organized large-scale entertainment for troops at the front during WWI and toured London boroughs with the Lena Ashwell Players.

ELIZABETH BAKER (1876-1962), a shorthand typist, began writing plays in 1907 and is best known for *Chains*, about the entrapment of men and women by work and social expectations. It was a big success, first as performed by the Play Actors Subscription Society at the Court Theatre in 1909, then at Duke of York's Theatre with Sybil Thorndike and Lewis Casson in the cast (revived at the Orange Tree in Richmond, 2007.) Her play *Edith* was presented at a WWSL matinee at Prince's Theatre, February 9th 1912. She lived in Esmond Rd, Chiswick.

JENNY (MRS HERBERT) COHEN was a member of wealthy west London Anglo-Jewish society and related to the Lowy family who were active suffragists, artists and patrons of the arts (the Lowys and Mrs Cohen sponsored poet Isaac Rosenberg to study at the Slade). She was a member of the WWSL and the Jewish League for Women's Suffrage, whose banner she made. She had several plays produced in London including *The Level Crossing,* produced by the Pioneer Players in 1914.

JESS DORYNNE was an actress and suffragist. Her daughter, Kitty, by Ellen Terry's son, theatre theorist Edward Gordon Craig, with whom she had a passionate affair, was born in 1900 after he had left her. In her play *The Surprise of his Life,* produced by the Pioneer Players, the working class heroine, in a similar situation, refuses to marry the father. She also published *The True Ophelia and Other Stories of Shakespeare's Women* in 1913, anonymously as 'by an Actress'.

BEATRICE FORBES-ROBERTSON (1883-1967) came from an acting family – her aunt was Gertrude Elliott, her uncle Johnston Forbes-

Robertson was knighted in 1913. Beatrice Forbes Robertson directed a Gertrude Jennings play for the Women's Exhibition in 1909 and wrote a short play herself. Around 1911 she gave a series of lectures on 'Drama as Social Education'.

Gertrude Elliot;
image courtesy of the
Museum of London.

GETRUDE ELLIOT (1874-1950) was a major actress, American by birth, but who built her career in Britain and was leading lady of actor-manager Johnston Forbes- Robertson whom she married in 1900. He was also a supporter of women's suffrage and was knighted in 1913. Her sister was the famous American actress Maxine Elliott. Gertrude was President of the AFL and was the mother of four daughters, two of whom became well-known actresses.

GABRIELLE ENTHOVEN (1868-1950) became a wealthy widow on the death of Major C.H. Enthoven in 1910. An amateur actress, she devoted her time and fortune to building up the extensive theatre collection that formed the original basis of the Theatre Museum, now the V&A Theatre Collections. She was a close friend of Radclyffe Hall, Ethel Smyth and Vera 'Jacko' Holmes and supporter of the Smallhythe household. One of her plays, *Ellen Young*, was produced by the Pioneer Players in 1916.

ROSINA FILIPI (1866-1930) was of part-Italian parentage and reputedly the half-sister of Eleanora Duse. She ran a successful acting school in Baker Street where many of her pupils went on to stardom including Hermione Gingold and Cathleen Nesbit. A member of the AFL, she wrote *Colonel and Mrs Henderson* for production at the Women's Exhibition, 1909. For some years Filippi also ran a touring company performing Shakespeare and playing in 1914 at the Old Vic under Lilian Baylis.

EVELYN GLOVER playwright and member of the AFL, produced several popular suffrage plays, *Miss Appleyard's Awakening* (Rehearsal Theatre, 1911), *A Chat with Mrs Chicky* (Rehearsal Theatre, 1912), *Which?* and the monologue *Showin' Samuel*. Later plays were produced by Inez Bensusan with the Rhine Army Theatre Company.

BEATRICE HARRADEN (1864-1936) was educated at Cheltenham Ladies College and Bedford College for Women in London where she gained a BA with honours in classics and mathematics. Harraden became a successful novelist with *Ships That Pass in the Night* (1893), *Hilda Strafford and the Remittance Man* (1897) and *Interplay* (1908) which features suffrage themes. A founder member of the WWSL, she was a very popular member of the suffrage movement and active in the WSPU. Her suffrage plays were *The Outcast* with Bessie Hatton and *Lady Geraldine's Speech* (both 1909).

KATE HARVEY (?-1946) became a heroine of the Women's Freedom League with her imprisonment in 1912 following a nine-month siege of her home in Bromley, when she refused to admit the bailiffs – she had failed to pay her servants' National Insurance stamps (introduced in 1911). Harvey was an intriguing figure: a physiotherapist, a playwright, deaf and the founder of a school for handicapped children in her home, she was the intimate friend of WFL leader Charlotte Despard. She later ran the WFL's International section. Her plays included *Baby* (Pioneer Players, 1911) and for the WFL: *Hiawatha* (1913) and *Courage* (1914).

BESSIE HATTON, actress and writer, was educated at Bedford College, London, one of the first women's colleges. Her novels included *Enid Lyle* (1894). In 1908, she wrote to congratulate Cicely Hamilton after hearing her speak and was recruited as secretary to the newly-formed Women Writers' Suffrage League. An excellent organiser, she worked with Inez Bensusan to encourage the writing of campaigning plays. Her own play *Before Sunrise* (1909) addresses the still taboo subjects of syphilis and sexual ignorance.

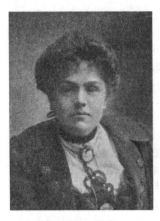

Marion Emma Holmes;
image courtesy of the
Museum of London.

MARION EMMA HOLMES (?-1943) was a suffrage activist in Margate, Kent and eventually Croydon, where she served at first as President of her local WSPU and did time in Holloway, before leaving to join the WFL, serving on its National Executive and as co-editor of *The Vote,* first with Cicely Hamilton, then with Mrs T.P. O'Connor. Her 'powerful dramatic sketch' *A Child of the Mutiny* was performed at suffrage events and *Brass and Clay,* about sexual double standards, appeared at the Woman's Kingdom Exhibition, 22nd April 1914. She also published 'cameo life sketches' on early feminist campaigners like Lydia Becker and other earlier feminists.

ANNIE HORNIMAN (1860-1937) was an heiress to the fortune of Horniman tea merchants (which also endowed the Horniman Museum). She first ventured into theatre by supporting a season of plays with her friend and fellow theosophist Florence Farr at the Avenue Theatre in 1894, including plays by Yeats and Shaw, and then supported the start of the Abbey Theatre in Dublin, 1904. Returning to England, she set up a season of plays at the Midland Hotel, and then in 1908, the Gaiety Theatre (both in Manchester), the first regional repertory company where she introduced many new local playwrights, often working in a realistic vein. She also encouraged women writers and supported the suffrage cause.

LAURENCE HOUSMAN (1865-1959) like his sister Clemence (see Artists) supported the suffrage cause and wrote a number of plays and monologues for performance by the AFL and others. He co-founded the Men's League for the Advancement of Women's Suffrage in 1907 (with Henry Nevinson and Henry Brailsford). His 'village plays' *A Likely Story* and *The Lord of the Harvest,* were performed in aid of the Suffrage Atelier at the Court Theatre in May 1910. His satirical *Alice in Ganderland* was performed at fundraising events all over the country and he wrote a new version of *Lysistrata* (1910) for the movement. His

play *Pains and Penalties: the Defence of Queen Caroline*, was produced by the Pioneer Players at the Savoy Theatre in 1911. A life-long socialist and pacifist, the bookshop he founded in support of these views remains open in Caledonian Rd, North London.

VIOLET HUNT (1866-1942) came from an artistic family whose friends included the Rossettis, John Ruskin and Oscar Wilde. Her mother was the novelist Margaret Hunt. Seen as a 'New Woman' of advanced ideas, she had a series of affairs and long-term relationships and lived with the already married Ford Madox Brown as his wife for ten years. A life-long feminist, she was a founder member of the Women Writers' Suffrage League and published twenty-five novels or collections of stories, many, such as *The Human Interest* (1899), addressing the sexual politics of relationships.

GERTRUDE JENNINGS (1877-1958) had a prolific career as a playwright for both the amateur and professional theatres. Her suffrage play, *A Woman's Influence* for the AFL was first produced at the Princes' Skating Rink in Knightsbridge for the Women's Suffrage Exhibition 13th-26th May 1909.

DAME MADGE KENDAL (1848-1935) was born into an acting family with whom she performed first at age six. She became recognised as a major actress with J.B. Buckstone's company at the Haymarket. With her husband, W.H. Kendal, she ran the St James Theatre. Also with the Bancrofts at the Prince of Wales, they are credited with bringing respectability and a middle class audience to the Victorian theatre. She supported the AFL and appeared at its founding at the Criterion in 1908. She was awarded a DBE in 1926.

DAME EDITH LYTTLETON (1865-1948) was born in Russia and grew up in establishment circles, marrying sportsman and politician, Alfred Lyttelton, in 1892. With Violet Markham she established the Victorian League to bring together high-ranking women across the political divide on the issue of empire. She was much involved in charitable and campaigning work, on the Executive Committee of the Women's Unionist and Tariff Reform Association, a vice president of the

Conservative and Unionist Women's Franchise Association and of the London Society for Women's Suffrage. She wrote seven plays, several on campaigning issues, and later became an ardent spiritualist. She was made a DBE in 1917.

MARGARET MACK (1874-1950) published her later work using the pseudonym 'Margaret Macnamara'. Her *The Gates of Morning* (Shaftesbury, 1908), about a fallen woman, was produced by the Incorporated Stage Society with Shaw's backing. Her socialist play *Unemployed* was produced at the Gaiety in Manchester by Annie Horniman in 1909, as was *Our Little Fancies* (1911). Several later plays were published. Many of Margaret Macnamara's manuscripts and notes are held in the Bristol University Women's Theatre collection. A number of later plays were published.

WINIFRED MAYO co-founded the AFL with Sime Seruya. She was also active in the Play Actors and in producing Bjornson's *A Gauntlet* for the Women's Theatre season. She appeared in *A Pageant of Great Women* as Jane Austen. Apart from an appearance in Hauptmann's *Hannele*, little is known of her professional career. In 1958, she recorded her recollections of Mrs Pankhurst and of smashing the windows of the Guards' Club, for the BBC.

LILLAH MACCARTHY (1875-1960) began her career with the Elizabethan Stage Society and Shakespeare Reading Society. She became a leading lady, touring South Africa and Australia with Wilson Barrett's company, then worked with Beerbohm Tree at His Majesty's. In 1905, Shaw cast her as Ann Whitefield in *Man and Superman* (1905) with Harley Granville-Barker, whom she married in 1906.

She became manager of the Little Theatre in 1911 and was closely associated as actress and director with Granville-Barker's experiments at the Royal Court and the Savoy theatres. A suffragist, she played Justice in the AFL's *Pageant of Great Women*.

M. SLIEVE MCGOWAN was a member of the WFL and a regular contributor to *The Vote*. Her play *Trimmings* was performed in a triple-bill in second of a series of 'trial performances for propaganda plays', with Vera Wentworth's *Allegory* and J. Maurice Hunter's *The Eclectic Club* at the Rehearsal Theatre on the 25th April 1911 and, produced by Madeleine Lucette Ryley, at the National WSPU's Christmas Fair and Festival 1911.

DECIMA MOORE (1871-1914) daughter of Edmund Henry Moore and Emily Strachan, was one of a family of five sisters, including Jessie and Bertha, all involved in theatre and active suffragists, most prominently Decima and her fellow actress-vocalist sister, Eva. Other sisters, elocutionist Emily Pertwee and Ada Moore, ran classes (at the Chelsea WSPU) to train suffrage speakers. The family gave 'theatrical performances at home – comedies and operettas'.

Decima made her debut in London aged seventeen, in 1889, playing Casilda in the Gilbert and Sullivan opera, *The Gondoliers*, the first of many successes. She divorced her first husband in 1902 and retired from the stage in 1914. Her second husband was colonial governor for the Gold Coast and she acted as exhibition commissioner for the colony's pavilion at several British Empire Exhibitions at Wembley.

Decima Moore;
image courtesy of Theatrewords.

EVA MOORE (1870-1955) was one of the best-known of the Moore sisters, all actresses or singers and suffrage supporters. Her husband HV Esmond (1869-1924) was a playwright whose suffrage play *Her Vote* was staged in 1910. Eva, like Decima, was a vice president of the AFL and served on their executive committee, lending their status to the campaign for women's suffrage. She also appeared in early films. Her daughter, Jill Esmond, married Laurence Olivier.

MARGARET WYNNE NEVINSON (1858-1932, née Jones) was a school manager and Poor Law Guardian and with her husband Manchester *Guardian* correspondent Henry Wood Nevinson, was a campaigner for social change. Her books and pamphlets included *Ancient Suffragettes* (1911), *Five Year's Struggle for Freedom: a history of the suffrage movement 1908-1912* and *Workhouse Characters* (1918). Her play *In the Workhouse* deals with the effects of the Law of Coverture on women and children.

ADELA PANKHURST (1885-1961) was the youngest daughter of the Pankhurst family and like her sister, Sylvia, a socialist. She focused her work for the WSPU on organising working women in the Yorkshire mills but her demanding schedule took its toll on her health. A combination of her ill-health and mistrust of Christabel's increasing emphasis on militancy, estranged her from her family and she was encouraged to take a job in Australia. She emigrated in early 1914. Her play *Betrayed* (1917), a political allegory, can be read as a thinly-veiled criticism of her family and their political betrayal.

'GEORGE PASTON' (1860-1936) was the pseudonym of Emily Morse Symonds. She was a novelist who wrote several works on the New Woman including *A Modern Amazon* (1894) and biographical studies of famous women. She became a vice president of the WWSL and her play *Stuffing*, was produced for the AFL/WWSL programme at the Aldwych Theatre, 18th November 1910. Her play *Clothes and the Woman* about men's tendency to judge by shallow appearances was staged by the Pioneer Players in 1907 and later that year in Annie Horniman's Midland Hotel season in Manchester.

MADELEINE LUCETTE RYLEY (1858-1934) was born in London, where she began her stage career. By 1881 she had emigrated with her family to the USA and was working on the New York stage, where she became known as an actress and singer in comic opera, creating the title-role in Gilbert and Sullivan's *Patience* in the US. Many of her seventeen plays scored major successes such as *Jedbury Junior* (1896), *Mice and*

Men and *An American Citizen* (1899). Her friends included fellow suffragist Gertrude Elliott and her husband Johnston Forbes-Robertson.

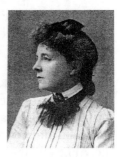

Ryley became a vice president of the AFL and a member of its executive committee, as well as a founder member of the WWSL, who published her *The Suffrage Question* in 1909. She played Catherine of Siena in *A Pageant of Great Women*, produced by the AFL (Scala, 1909). Her niece Jane Comfort was also an actress and AFL member.

Madeleine Lucette Ryley; image courtesy of Sherry Engle.

SIME SERUYA (1875-1955) was part Portuguese by birth and an actress. She was one of the founders of the AFL with Adeline Bourne, Winifred Mayo and Gertrude Elliott. She was a member of the WFL and with Edith Craig organised their contribution to the great Women's Suffrage Procession in 1910. She was also a socialist and member of the ILP. She was arrested and imprisoned and in 1911 fought successfully against a further conviction for selling *Votes for Women* on the steps of the Lyceum. She lived in West Lewisham.

ATHENE SEYLER (1889-1990) studied at RADA in 1908 (it had been founded in 1904) and made her first appearance on stage in 1909 and joined the AFL around the same time. She lived at 97 Esmond Rd, Chiswick from 1914-16 and was married from there. She played Jill in Cicely Hamilton's *Jack and Jill and a Friend* for the Pioneer Players in 1911. She was also a member of the Theatrical Ladies Guild. She later successfully expanded her career into screen and television, known for playing rather dotty old ladies. She became President of RADA in 1950 and was awarded a CBE in 1959.

MABEL ANNE ST CLAIR STOBART (1862-1954) had an adventurous life in the Transvaal as a young wife and mother and is best-known for her wartime exploits founding the Women's Convoy Corps and the Women's National Service League, setting up field hospitals in Serbia and becoming famous as 'the lady on the Black Horse'. Her play *Meringues*,

one of several she wrote, was presented at the Women's Exhibition in 1909. She later became a spiritualist.

SYBIL THORNDIKE (1882-1976) was cast by Annie Horniman in the first season of the Gaiety Theatre, where she met Lewis Casson, her future husband (later the director of the Gaiety). He introduced her to socialism and women's suffrage. She became a member of the WSPU and the AFL and met Edy Craig. She played Maggie in Elizabeth Baker's *Chains* and later several roles for the Pioneer Players including, in 1925, Claire in Susan Glaspell's *The Verge* (revived at Orange Tree Theatre in 1996). Her best-known role was as Shaw's *St Joan*.

VIOLET VANBRUGH (1867-1942) was one of the major Edwardian actresses, who, like Ellen Terry, supported the AFL when it was launched in December 1908, under the glittering gold ceiling of the Criterion Restaurant. So did her sister, **IRENE VANBRUGH** (1872-1949), who became a vice president of the AFL though they were determinedly non-militant in their politics. They were the daughters of Prebendary of Exeter Cathedral and their careers on stage were seen as an indication of its increased respectability. Violet played Gwendoline in Wilde's *The Importance of Being Earnest* (1895). Both also married into theatrical families.

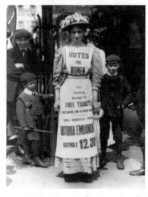

Vera Wentworth draws attention to the cause; image courtesy of Elizabeth Crawford.

VERA WENTWORTH (1890-1957) was born Jessie Spinks, and was a shop assistant, who like her brother Wilfred Spinks became swept up in the suffrage movement. A militant WSPU member, she was seven times imprisoned for her political activities. She later studied at St Andrew's University. Her play *An Allegory*, written for the Actresses' Franchise League, was performed in Holloway and at suffrage events.

EDITH ZANGWILL (1879-1945) was a novelist, born into a radical family (her grandmother Matilda Chaplin signed the 1866 suffrage petition, her stepmother was the first woman elected to the Institution of Electrical Engineers) and a member of the Tax Resistance League. Her husband was writer Israel Zangwill, a well-known Jewish socialist and pro-suffragist.

Among her novels, *The Call*, dedicated 'to all those who fought for the Freedom of Women', is most popular. Based on the experiences of a woman scientist in the First World War it describes the dismissal by the war office of a life-saving invention because it was by a woman.

ISRAEL ZANGWILL (1864-1926), husband of Edith, grew up the son of an immigrant Jewish family in London's East End (an experience reflected in his *Children of the Ghetto*). A socialist, pacifist and pro-suffragist he wrote *Prologue* (see pp44-45) for the Croydon WSPU and it was then performed by the AFL at the Lyceum 1911. AFL members were in the casts of his own play *The Melting Pot* about Russian Jewish immigrants (featuring Bensusan) and *The Next Religion* (featuring Adeline Bourne).

7. ~ MUSIC ~

March of the Women

Music was central to the suffrage movement. Singers and musicians from music hall to light opera were among those who joined the AFL. Suffrage anthem writers adopted well-known tunes with new words to sing at rallies and on marches. Popular anthems were *Rise Up, Women* (to the tune of *John Brown's Body*); *Shoulder to Shoulder* (to *Men of Harlech*) and the *Women's Marseillaise* penned by Florence E.M. Macaulay in 1909:

> 'Arise, ye daughters of a land
> That vaunts its liberty.'

Suffrage musicians played in drum and fife bands on marches. Ladies' orchestras and women soloists performed at benefits. The Society of Women Musicians, established in 1911, found it hard to distance itself, as some desired, from the suffrage issue, declaring there is 'nothing in common between votes and notes'.

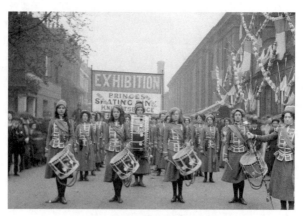

The women's drum and fife band;
image courtesy of the Museum of London.

ETHEL SMYTH (1858-1944)

The Society's most prominent figure Dr (later Dame) Ethel Smyth was already an established composer. She went to prison for window-breaking and composed the enduring suffragette anthem: *March of the Women* with words by Cicely Hamilton. It was the theme tune for the 1974 BBC TV series, *Shoulder to Shoulder.*

'In those early days of my association with the WSPU occurred an event which, in her pride, the writer must recount ere the pace becomes such that a personal reference would be unthinkable, namely the formal introduction to the Suffragettes of 'The March of the Women', to which Cicely Hamilton fitted the words after the tune had been written – not an easy undertaking. A suffragette choir had been sternly drilled, and I remember Edith Craig plaintively commenting on the difficulty of hitting a certain E flat. But it was maintained that the interval is a peculiarly English one (which is true) and must be coped with. We had the organ, and I think a cornet to blast forth the tune (a system much to be recommended on such occasions), and it was wonderful processing up the centre aisle of the Albert Hall in Mus. Doc. robes at Mrs Pankhurst's side, and being presented with a beautiful baton, encircled by a golden collar with the date, 23rd March 1911.'

Ethel Smyth, from *Female Pipings in Eden*

(See Chapter 15 for a Collection of Suffrage Anthems)

8. ~ SPREADING THE WORD ~

Much of the suffrage movement's energies were focused on spreading the word, recruiting women and men to support the cause. Throughout the country, local branches and professional women's suffrage groups poured their energies into co-ordinating programmes of meetings, rallies, fundraisers, bazaars, reading groups and lectures, including educational gatherings aimed at working men and women. In fact, few women of any class had had access to a broad education. This section gives examples of a range of such initiatives, with particular reference to West London.

Meetings

The AFL held regular meetings at the Criterion restaurant and the New Reform Club:

1910-11 Monthly 'At Homes'

'We are glad to be able to report that success and popularity continue to attend our "At Homes" at the Criterion every month. Besides these important guests, we find they attract the most obstinate of antis and, more important still, members of that class most difficult of all to get at "the women who take no interest at all" in Votes for Women and have never been to a Meeting before. Our Patrons Book bears witness to the fact that this is no longer true when they leave!'

At the New Reform Club the AFL addressed more troublesome issues:

'Suffragette Tactics'
'That a knowledge of politics is not injurious to dramatic art'
'That the Stage conception of Woman is conventional and inadequate'

while at 'A Meeting For Women Only' chaired by Lena Ashwell on Friday June 6th 1913, 3pm, Miss Abadam White spoke on 'Slaves Supply and Demand' – the white slave trade. Tickets were 1/- or 6d.

Platform Speakers: Richmond-upon-Thames and Wimbledon

BETRAND RUSSELL (1872-1970)

In 1907, the philosopher and Richmond-upon-Thames resident Bertrand Russell unsuccessfully stood for election on a Women's Suffrage platform at the Wimbledon Parliamentary by-election. Russell remained an outspoken social critic and was the founding President of the Campaign for Nuclear Disarmament. His wife Dora (1894-1986), feminist, pacifist and writer, contributed an entry to the *Suffrage Cook Book*:

Recipe for Cooking and Preserving a Good Suffrage Speaker

First: Butter the speaker, when asking her to come, with a stamped and addressed envelope, post card, or telegraph form for reply.

Second: Grease the dish by paying all the speaker's expenses.

Third: Put her to cool or to warm, as the case may be, in a room by herself before the meeting, so that she may be fresh and in good condition for speaking.

Fourth: Beat her to a froth with an optimistic spoon, making light of all disappointments. Carefully avoid too strong a flavour of apologies.

Fifth: Do not let her cool too rapidly after the meeting, but place her considerately by a nice bedroom fire, with a light supper to be taken in solitude.

(If this recipe is carefully followed, the speaker will be found to preserve her flavour to the last moment, and will do her utmost to make the meeting a success.)

Mrs Bertrand Russell, Bagley Wood.

LADY FRANCES BALFOUR (1858-1931)

A speaker who would have appreciated such care and attention was The Lady Frances Balfour. Born into the aristocracy, Lady Frances had grown up helping her parents with their many campaigns for social reform.

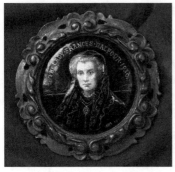

Portrait of Lady Frances Balfour enamelled by Ernestine Mills; image courtesy of the family of Lady Balfour, © V. Irene Cockroft, photo David Cockroft.

Blessed with an excellent platform voice, she served as President of the London Society for Women's Suffrage and also of its Richmond branch, attending many suffrage events and rallies.

Lady Frances married architect Eustace Balfour. She tried to persuade her brother-in-law, Conservative Prime Minister Arthur Balfour, to support the cause of women's suffrage. In spite of wielding considerable influence with the PM behind-the-scenes, Lady Frances achieved limited public success in converting him to the Cause.

Soapbox Oratory: ROSE LAMARTINE YATES (1875-1954)

'There is a woman at the beginning of all great things.' This was a saying of Alphonse Lamartine (1790-1869), French writer, poet and politician. Lamartine was a political idealist who supported democracy and pacifism. His politics, radical and liberal, probably reflected those of Elphège and Pauline Janau, teachers from France who settled in England where they married in 1870. They were certainly to foreshadow the politics of their daughter Rose and her husband Tom Lamartine Yates.

By a twist of fate, Lamartine was to become their daughter's middle name on marriage to an English solicitor whose father must have been an admirer of the French poet and statesman. In 1900, Rose Janau married Tom Lamartine Yates, solicitor and widower, a family friend twenty-seven years her senior. They had been drawn together by their common interest in cycling.

Rose had graduated from Royal Holloway College where she studied languages (but as a woman she was not entitled to be awarded a degree). She

studied law with Tom in order to help him with his law practice. In doing so she became aware of the inequity in law between men and women. Her determination to right this wrong made Rose a militant suffragette for, she wrote, 'to fight without any weapon that stings is to fight in vain.' She was to become treasurer and organising secretary of the lively Wimbledon Women's Social and Political Union.

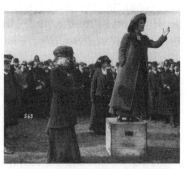

Rose speaks her mind to regular crowds of a thousand on Wimbledon Common; image courtesy of the John Innes Society of Merton Park.

That this was a supportive marriage is attested by Tom's 1909 birthday letter to Rose. It contained the sentence, 'The present I give thee is not gold or silver but permission freely and gladly, to offer up thy liberty for the benefit of downtrodden women.' This was a reference to an impending prison sentence after Rose's arrest for taking part in a deputation to Prime Minister Asquith to protest at the omission of the pressing subject of Women's Suffrage from the King's Speech. In spite of being represented by Tom in court, and of being the mother of an eight-month-old baby, Rose was sentenced to one month in prison in the 2nd (criminal) division.

This gave rise to an anti-suffrage poem in *Punch* magazine of 10th March 1909:

A Mother's Sacrifice

[To a Suffragette who, on being brought before the magistrate, made the following statement (according to *The Daily Telegraph*):

'I have a little son, eight months old, and his father and I decided, after calm consideration, that when that boy grew up he might ask, "What did you do, mother, in the days of the women's agitation, to lay women's grievances before the Prime Minister?" and I should blush if I had to say I made no attempt to go to the Prime Minister.']
And so this boy of yours, years hence perusing
Records of women wronged by man-made laws,
May ask, an eager flush his face suffusing,

"What did you do to help the Women's Cause?"
If, when this searching question has arisen,
You answer, "Nothing," picture his surprise!
'Twere better to endure the pains of prison
Than face the scorn in those reproving eyes.
Let it be his to hear the tale – and may be
It will not lose through being often told –
How you renounced your husband, home
and baby,
When he (the last-named) was but eight months old.
Such be your answer! Yet, O happy mother,
Is this the only question you foresee?
What will you say, suppose he asks another: -
"Meanwhile, dear Parent, who looked after me?"

Paul with his mother
supporting the Cause;
image courtesy of the
John Innes Society of
Merton Park.

Rose's response was published in a different
publication under the title, *Little Paul's Reply*:

From Her Baby's Point of View

'Dear Mr Punch, I'm happy with my dadsie,
Who makes me laugh while snug in nurse's arm,
And sings the tunes I used to hear from mummie;
So do not cause yourself undue alarm.
And yet you think that I might ask my mother,
Who, in her absence, undertook my care?
But do you ever worry when another
Leaves home and babe to seek mere pleasures rare?
I'd rather know my mother, self-repressing,
Went bravely forward, fearless of her doom,
That she might save her sex from lot distressing,
And shame the men who dole out prison gloom.
But, Mr Punch, 'twere time you had some schooling,
For mothers are not parents by our laws;
'Tis fathers only, by all legal ruling;
So children, too, must help the woman's cause!'

 'Little Paul'

Rose had a gift for expressing argument cogently as a writer and as an orator. In an article in the Wimbledon and Merton Recorder she attacked the argument that 'A woman's place is in her home.' She wrote:

'In what sense is it her home? Is she the recognized owner of it? No, 'tis the father or the husband. Is she the owner of the goods within it? No. Are they her children? No, the law of the land says not, they are the father's property; the mother may not claim to be the legal parent of her child.'

According to law a man could stipulate that after his death his children were to be brought up by a person other than his wife.

There was also the matter of the right to vote. From her soapbox stand on Wimbledon Common, Rose pointed out that British adults denied the vote were the financial underclass, convicted criminals, lunatics and women. A man could improve his finances, be released from prison, and regain his reason. He would then be eligible to vote. But a female was branded from birth to death, lower than all these. Being born female was her crime and the penalty was lifelong exclusion from citizenship.

The outdoor oratory of Rose and suffrage colleagues like artist sisters Georgina and Marie Brackenbury, attracted huge crowds on the common. Thousands attended and sometimes there was trouble.

In 1913, three hundred police guards were insufficient to control the crowd. Troublemakers attacked the women, who took shelter in a sympathiser's home nearby. As a result of such scenes, the home secretary tried to prevent the WSPU from holding public

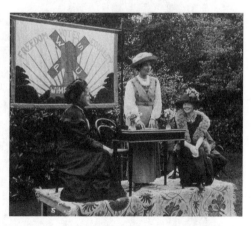

Speakers on the Dorset Hall platform are (from left) Georgina Brackenbury, Rose Lamartine Yates and Winifred Mayo, founder member of the Actresses' Franchise League; image courtesy of the John Innes Society of Merton Park.

meetings in open spaces. Rose and the Wimbledon WSPU maintained they had the right to free speech and carried on with their meetings regardless. Eventually, they won crowd acceptance.

Rose's birthday present from Tom in 1910 was delivery of forty-eight chairs for the WWSPU meeting room. In 1911, it was a clock for the WWSPU shop at 6, Victoria Crescent (later renumbered 9, demolished 1994), 'to mark time till the vote is won'.

The WWSPU shop stocked produce from the extensive grounds at Rose's home, Dorset Hall. Rose was a keen gardener who grew her own fruit and vegetables. The shop also stocked stationery, postcards, china, Veda bread, home-made marmalade, Votes for Women soap (indelibly marked) and the WWSPU's own packaged tea. Home-made children's clothing was popular. The WWSPU stall at the 1909 Women's Exhibition specialised in children's clothing, making the point that being a respectable family woman was not inconsistent with political action when called for.

The Garden Party

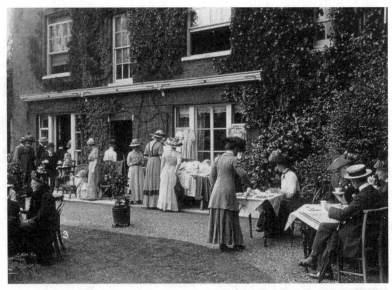

Dorset Hall garden party; image courtesy of the John Innes Society of Merton Park.

The grounds of Dorset Hall in Wimbledon, home of Tom and Rose, were the scene of much activity on behalf of the Women's Cause.

A garden party was a popular method of raising suffrage campaign funds. Dorset Hall offered the perfect garden for parties.

The WSPU commissioned a branded china tea set to be produced for use at public events and for sale. The trumpeting angel or portcullis designs used were by Sylvia Pankhurst. (WSPU china can be seen in use at Dorset Hall here in the photograph.)

In 1912, released hunger-striking suffrage prisoners Edith Marion Begbie, Flo McFarlane and Gertrude Wilkinson were feted at Dorset Hall.

In June 1913, a tragedy unfolded. Emily Wilding Davison in trying to gain attention for the Cause by attaching a WSPU banner to a horse running in the Epsom Derby, was fatally injured.

Rose Lamartine Yates found herself in charge of the aftermath of the tragedy. Although Emily never recovered consciousness, Rose visited her in the Epsom Cottage Hospital where she was cared for. For Emily's few last days, Rose decked the hospital room in WSPU colours. Rose and Tom Yates invited Emily's brother to stay at Dorset Hall whilst funeral arrangements were made there by suffragettes including Mary Leigh. Rose was 'first guard of honour' to the coffin between Epsom and King's Cross. Tom represented the Davison family at the inquest.

The funeral of the suffrage campaign martyr was closely followed by the burning down of Hurst Park Racecourse Stand in retaliation for the death; and the subsequent arrest and prosecution at Surrey Assizes court in Guildford of actress Kitty Marion and of Clara Giveen.

9. ~ FORMS OF PROTEST ~

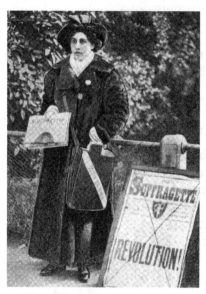

Princess Sophia Duleep Singh (1876-1948) sells *The Suffragette* outside Hampton Court; image courtsey of the Museum of London.

Tax Resistance

In 1909, women set up the Tax Resistance League. Its members included writer Beatrice Harraden, Edith Zangwill, Kate Harvey and Sophia Duleep Singh, daughter of a Maharajah exiled from the Punjab. Princess Sophia lived in a grace-and-favour apartment at Faraday House, Hampton Court provided by her godmother, Queen Victoria.

Taken to court for non-payment of taxes she remained defiant, declaring: 'If I am not a fit person for the purposes of representation, why should I be a fit person for taxation?'

When bailiffs seized jewellery to the value of the debt, suffrage supporters bought it back at auction, using the event to gain publicity for the cause.

Census Boycott

Many suffrage supporters boycotted the census of 1911, spoiling their census returns with statements like: 'No persons here, only women', or 'If I am intelligent enough to fill in this paper, I am intelligent enough to put a cross on a voting paper'. Some went to the Aldwych Skating Rink, where AFL members entertained them.

Punch magazine quipped that the ladies 'must have taken leave of their census'.

The Argument of the Broken Window

Also in 1909, the militant suffragettes stepped up their campaign against the Liberal Government's inaction by breaking windows in Whitehall and tearing slates off the roofs of public buildings.

Alice Chapin and Alison Neilans of the Women's Freedom League were arrested and Chapin imprisoned for pouring acid into a ballot-box, after a teller was slightly splashed with acid. Pillar boxes were set alight or filled with ink or corrosive liquid. In Kew, 1912, letters were found soaked with potassium permanganate after a large uncorked bottle was posted in the box in an envelope marked 'Votes for Women'.

Arrested and imprisoned, women campaigned for treatment not as criminals but political prisoners. When this failed, they hit back with hunger strikes. In response, the Home Secretary brought in forcible feeding, where a prisoner was held down by warders, while a tube was passed down her throat or nose, and food administered that way.

KITTY MARION (1871-1944)

Kitty was born in Germany but moved to Britain where she worked as a music hall artiste and actress. She joined the WSPU and was arrested many times, first for throwing stones, then for her involvement in the WSPU arson campaign.

In June 1913, she and Clara Giveen were arrested in Richmond-upon-Thames, Surrey, having burnt down the Grandstand at Hurst Park Racecourse, West Molesey in retaliation for the martyrdom of Emily Wilding Davison at the Derby. Sentenced to three years' penal servitude for this and three other fires, she went on hunger strike. Over her suffrage career, she served seven prison terms, undergoing nearly 200 force-feedings.

Deported to the US in 1915 (for her opposition to the War and due to her German birth) she became active in the birth control movement.

Kitty Marion released from prison; image courtesy of the Museum of London.

LILIAN LENTON (1891-1972)

Lilian was a dancer who joined the WSPU at the age of twenty-one after listening to a speech by Emmeline Pankhurst. She began by smashing windows and was arrested in February 1913 on suspicion of setting fire to the Tea-House, Kew Gardens. Forcibly fed in Holloway, she became ill with pleurisy caused by food entering her lungs. The political embarrassment of her case caused the Government to pass the notorious Cat and Mouse Act where hunger-striking suffragettes could be released for brief periods to recover their health, only to be re-arrested.

Lilian was awarded a Red Cross medal for her work as a nurse in World War I. She later came to live in Twickenham.

Home Office surveillance picture of Lilian Lenton; image courtesy of The National Archives, reference AR1/528.

Hunger Strikes

'27th September 1909: Suffragettes in Prison (Supply of Food) – Hansard'

'KEIR HARDIE: I beg to ask the Secretary of State for the Home Department whether he has any official information concerning the state of health of Mrs Leigh and Miss Marsh, prisoners in Winson Green, Birmingham, and whether it has been found necessary to administer food to those ladies by force, and, if so, under what authority this action was taken or under what prison regulation this action was taken?

Mr. MASTERMAN: The medical officer of Birmingham Prison reported that certain women prisoners have persistently refused to take food. The Prison Commissioners therefore, with the approval of the Home Secretary, instructed the medical officer to apply such ordinary medical treatment as was, in his opinion,

necessary to prevent the risk of their committing suicide by starvation. The treatment is the ordinary hospital treatment in such cases.

Mr. KEIR HARDIE: Can the hon. gentleman say if the full operation is the food being pumped through the nostrils of these women or inserted by a tube down the throat? What has been the treatment?

Mr. MASTERMAN: I think the ordinary method is the second one.

Mr. KEIR HARDIE: The tube is inserted into the stomach and food pumped into it — horrible outrage, beastly outrage. The last man died who was treated in this way.'

Kitty Marion, from her unpublished memoir.

'My hunger strike had begun. Neither food nor water had passed my lips for two days. About midday, a wardress brought my dinner and strongly advised me to eat it. There was a grim note in her voice which sounded very ominous and I felt prepared for the worst. In the evening I decided to barricade my cell with the table and bed wedged against the door. They chiselled the hinges off and lifted the door out. Two wardresses asked me to come with them, I refused and, struggling all the time, they managed to drag me to the doctor's room, where three doctors awaited me.

One asked me to drink some milk. I refused and was seized and forced into an arm chair, covered by a sheet, each arm held to the arm of the chair by a wardress, two others

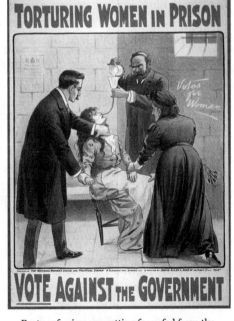

Poster of prisoners getting force fed from the National Women's Social and Political Union c.1909.

holding my shoulders back, two more holding my knees down, a doctor holding my head back. I screamed all the time. Not knowing the procedure of forcible feeding and thinking it was done through the mouth, I clenched my teeth when they had me in position and helpless. Then suddenly I felt something penetrate my right nostril which seemed to cause my head to burst and eyes to bulge. Choking and retching as the tube was forced down to the stomach and the liquid food poured in, most of which I vomited back when the tube was withdrawn.

I must have lost consciousness for I found myself flat on the floor. The wardresses tried to sympathise with and soothe me but I asked them to leave me alone and pushed them out. I cried with rage until I heard screams and knew that someone else was going through the same torture.'

Extract from *The Suffragette Movement* by Sylvia Pankhurst

Imprisoned on July 8th, 1913, after holding a suffrage meeting in Bow in London's East End at which she instigated breaking windows, Sylvia recounts how she went on thirst as well as hunger strike and her experience of the ordeal of forcible feeding.

On the third day of thirst and hunger strike, a crowd of wardresses entered Sylvia's cell.

'There were six of them, all much bigger and stronger than I. They flung me on my back on the bed, and held me down firmly by shoulders and wrists, hips, knees and ankles. Then the doctors came stealing in. Someone seized me by the head and thrust a sheet under my chin ... I set my teeth and tightened my lips over them with all my strength. A man's hands were trying to force open my mouth; my breath was coming so fast that I thought I should suffocate. His fingers were striving to pull my lips apart – getting inside. I felt them and a steel instrument pressing round my gums, feeling for gaps in my teeth. I was trying to jerk my head away, trying to wrench it free. Two of them were holding it, two of them dragging at my mouth... "Here is a gap," one of them said ... A steel instrument pressed my gums, cutting into the flesh ... A stab of sharp, intolerable agony

... Then something gradually forced my jaws apart as a screw was turned; the pain was like having the teeth drawn. They were trying to get the tube down my throat. They got it down, I suppose, though I was unconscious of anything then save a mad revolt of struggling ... I vomited as the tube came up ... The same thing happened in the evening... Day after day, morning and evening, the same struggle ...'

Bronze maquette of Sylvia Pankhurst by the late Ian Homer Walters (1930-2006) socialist sculptor whose subjects included Nelson Mandela and Harold Wilson. In May 2006, the Society of Portrait Sculptors presented Walters with its highest award, the Jean Masson-Davidson Silver Medal, in recognition of his lifetime achievements. Planning permission was obtained for his statue of Sylvia Pankhurst, intended to stand on College Green, opposite the House of Lords; image courtesy of The Sylvia Pankhurst Memorial Committee, photo David Cockroft.

10. ~ OFF WITH CORSETS!
THE FASHION REVOLUTION ~

Latest Paris fashions from
The Queen magazine 1884;
image courtesy V. Irene Cockroft,
photo David Cockroft.

In the 19th century, fashion dictated tight-laced corsets, pipe waists and plenty of layers. No wonder Victorian women were prone to fainting. Medics and artists fulminated against such dangerous and unnatural constriction; medics because vital organs and reproductive capacity could be damaged, artists because woman's natural shape was more aesthetically pleasing.

Among vice-presidents of the Healthy and Artistic Dress Union founded in 1890 were artists Henry Holiday, Walter Crane, Mr and Mrs Thorneycroft and Mr and Mrs GF Watts.

In 1883, Watts had written a diatribe against unhealthy fashion, 'On Taste in Dress' that led to his adoption as President of the Norwood Anti-Tight-Lacing Society. In Watts' opinion, tight-lacing 'destroyed the balance, beauty, pliancy and variety of nature, and forced the heart and lung cavities to contract, crumpling the ribs.' Indeed, the death of a young girl about this time was officially attributed to pressure round the waist.

It did seem paradoxical that, ostensibly in order to attract a mate, young women should risk harming those very reproductive organs that mating was all about.

Unfettered *New Woman*, informed by the Healthy and Artistic Dress Union and Rational Dress League, agreed.

The Rational Dress League.

THE inaugural meeting of the Rational Dress League was held recently in the St. Martin's Town Hall (the Lower Hall), which was packed with a sympathetic audience of both sexes.

Viscountess Harberton, who presided, urged the importance of dress reform from a common-sense point of view, and in a powerful speech pointed out the advantages of the divided garment, and the absurdity of the present restrictions. She wondered at the stupidity of mankind, who could not, or would not, look at the question from a commonsense standpoint. All they wanted was a sensible garment which would give free play to the lower limbs. In time this could be made as pretty and artistic as desired. But the truth was that the tribal influence still prevailed, and men looked upon women as creatures whose place was by the fireside, and whose duty it was to wait upon them. For this life of inactivity their present dress was certainly suitable, and it was therefore, in the eyes of men, the one and only possible feminine dress. But the change was bound to come, and to speed its coming the League had been formed.

In her memoir *Period Piece*, Gwen Raverat enumerates the layers of clothing a young lady wore in the 1890s:

1. Thick, long-legged, long-sleeved woollen combinations
2. Over them, white cotton combinations, with plenty of buttons and frills
3. Very serious, bony, grey stays, with suspenders
4. Black woollen stockings
5. White cotton drawers with buttons and frills
6. White cotton 'petticoat-bodice' with embroidery, buttons and frills
7. Rather short, white flannel petticoat
8. Long alpaca petticoat with a flounce round the bottom
9. Pink flannel blouse
10. High, starched white collar fastened on with studs
11. Navy-blue tie
12. Blue skirt, touching the ground and fastened tightly to

the blouse with a safety-pin behind
13. Leather belt, very tight
14. High-buttoned boots

In response to such restriction, the bifurcated skirt (culottes) and American Bloomer costume enjoyed a short season in vogue whilst fashion flirted with the fine line between physical freedom and looking 'fast'.

The simplicity of suffragette blouse and skirt suited demanding occasions like Women's Sunday held in Hyde Park on 21st June 1908. According to the *Daily Chronicle* a crowd of around 300,000 attended. It also suited that liberating force for women, bicycling.

By the 1930s, members of the keep-fit Women's League of Health and Beauty were claiming the right to practice sports in shorts in parks! Men ceased objecting that the healthy female form was 'unwomanly'.

Votes for Women, May 14th, 1909, p67

Votes for Women 16th April 1909, p559

11. ~ GILDING THE LILY ~

Badges

In 1892, a poem by Laura Morgan-Brown was published in *Woman's Herald*. It advocated the wearing of:

'A little badge, a simple badge,
With a magic word upon it,
To bravely wear upon the breast,
Or decorate a bonnet,
Or ring oneself with cherished bond,
Or tie it round the throat;
A badge – in any shape you please
With superscription Vote!'

Almost two decades were to pass before, around 1909, the suggestion blossomed into badges bearing the red rose with white and green of the National Union of Women's Suffrage Societies; a purple, white and green trumpeting angel pendant designed by Sylvia Pankhurst for the Women's Social and Political Union; and the metal flag badge with bars of green, white and gold enamel favoured by the Women's Freedom League.

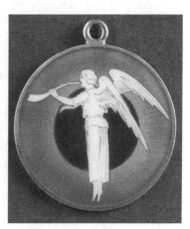

Sylvia's trumpeting angel design used on an enamelled pendant. Design © Richard Pankhurst OBE; image courtesy of Elizabeth Crawford.

From 1900, suffrage societies representing the special interest of groups such as the Actresses' Franchise League, Artists' Suffrage League and Church League for Women's Suffrage proliferated. Badge-wearing became

a useful means of identifying groups and interests, of initiating conversations among strangers, of demonstrating that 'the spirit of the age' was well supported by women from many backgrounds, and of attracting new recruits.

Badges were generally manufactured by commercial suppliers such as Toye and the Merchant Portrait Co.

Presentation Jewellery

Another class of identification, establishing status and encouraging emulation, was presentation jewellery. Into this category falls the WSPU 'Holloway' badge designed by Sylvia Pankhurst – 'the Victoria Cross of the Union'. The silver portcullis and chain badge with enamelled purple, white and green arrow was presented to those who had been imprisoned for the Cause, on their release, usually at an impressive ceremony.

Hunger-strike medals, engraved with name on one side and 'Hunger Striker' on the other, were hung on a purple, white and green ribbon from a silver pin bar engraved 'For Valour'. Where hunger strikers had additionally endured forcible feeding, a bar enamelled in the colours was added. Engraved on the back was 'Fed by Force' and the date.

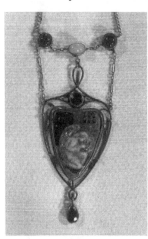

'Angel of Hope' pendant by Ernestine Mills © V. Irene Cockroft, photo David Cockroft, courtesy of the Museum of London.

In addition to regalia type jewellery, symbolic 'honour' jewellery might be commissioned by society members to honour a particular person or occasion. At least two pendants in this category are known to have been made by art-enameller and suffrage campaigner Ernestine Mills. One depicts an 'angel of hope' playing her lyre outside the wall of Holloway prison to comfort the political prisoner languishing inside. This was presented to Louise Eates, secretary of the Kensington WSPU, on her release from prison in 1909.

The other pendant is enamelled with a lily for purity; white lily, green stem, purple

background. Its recipient was a Dubliner. The reverse is engraved, 'Holloway Prison No. 15474, Maggie Murphy, 2 months hard labour, E.4 Cell 12, Hunger Strike 16th April 1912, Forcibly Fed.'

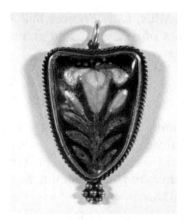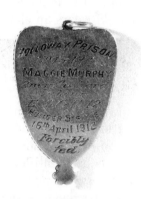

Maggie Murphy lily pendant by Ernestine Mills, front and back; ©V. Irene Cockroft, photo David Cockroft.

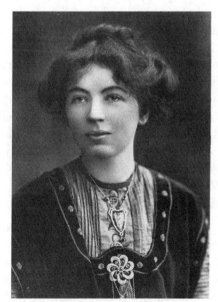

Christabel postcard courtesy of V. Irene Cockroft.

When Emmeline Pankhurst was released after serving a prison sentence, in January 1909 she was presented by faithful WSPU members with a necklace and pendant wrought in gold with amethysts, pearls and green agates. *Votes for Women* of 17th December 1908 reported the commissioning of the jewellery but unfortunately not the maker.

Flora Drummond, in her portrait painted by Flora Lion that hangs in the Scottish National Portrait Gallery, is wearing her hunger strike medal and an impressive

pendant of purple, white and green stones. This was almost certainly a presentation piece for 'General Drummond'. Flora was held in affectionate regard by the many WSPU members she led, mounted on horseback, in WSPU parades.

In a portrait in enamel by Ernestine Mills, Lady Frances Balfour of the NUWSS wears an elaborate pendant of red, white and green, the colours of the Constitutional campaigners.

Personal Jewellery

Purple, white and green gems, and indeed the many other colour combinations chosen to represent suffrage organisations, were not uncommon in Victorian and Edwardian jewellery. Hence for items of jewellery to be identified as suffrage inspired, it is helpful to know whether the maker had suffrage sympathies.

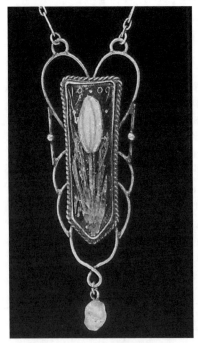

1909 pendant by Ernestine Mills;
© V. Irene Cockroft, photo
Tadema Gallery.

Arts and crafts designer John Paul Cooper is known to have made jewellery in distinctive purple, white and green. Examples of his work may be seen at the Cecil Higgins Art Gallery, Bedford. Mappin and Webb produced a catalogue of suffrage jewellery in enamel and gems, and advertised in *Votes for Women*. Individual women craft workers also advertised their jewel creations 'in the colours'. In 1909, Miss Myers contributed bead necklaces to the WSPU Prince's Skating Rink Women's Exhibition.

Ernestine Mills donated £10 worth of enamelled jewellery to the Women's Exhibition jewellery stall to help swell campaign funds. At a time when women in the textile trade earned on average 15/6 a week and men earned

28 shillings, this was a sizeable sum.

Although gold, silver, gemstone and enamel jewellery is expensive, relatively inexpensive bead necklaces of the suffrage period in purple, white and green occasionally may still be found on market stalls.

In another category is the sumptuous jewellery worn to good effect by Actresses' Franchise League member Ellen Terry. Princess Sophia Duleep Singh of the Tax Resistance League had her jewellery distrained by the court and sold for non-payment of taxes. Daughter of a Maharajah exiled by the British from the Punjab, Sophia's jewellery may have been very exotic and valuable indeed. She must have been relieved to have it bought back for her by other members of the League who used the auction as a platform for attracting publicity for the Cause.

How Tax Resistance Served the Suffrage Campaign

Votes for Women 6th June 1913 p526

'On May 21st Mrs Cecil Chapman, the wife of the well-known London magistrate, had a ring sold by distraint at Battersea on account of her refusal to pay Property Tax. A very large crowd was present in the auction rooms, but there was only one bid for the ring, this being the exact amount required to pay the tax. Mrs Chapman was then called upon to address the people in the room, who were most enthusiastic, and subsequently a meeting was held at the Battersea Town Hall.'

12. ~ CONTEMPORARY RESPONSES TO THE SUFFRAGE MOVEMENT ~

The suffrage movement continues to inspire artists and writers.

Television

In the post-war period dramatisations of the suffrage struggle have included Midge Mackenzie's legendary BBC television series *Shoulder to Shoulder* in 1974.

The programme grew out of Mackenzie's own involvement in the new wave of feminism and political struggle, her earlier series *Women Talking* (1970) and her own passionate commitment:

Sian Phillips as Emmeline Pankhurst in TV series
Shoulder to Shoulder, Midge Mackenzie (1938-2004);
image courtesy of the BBC photo library.

'Working as a maverick, outside the mainstream, Midge Mackenzie, with her passion for championing the underdog, forged a one-woman industry with needs-must attitude. She overcame the daunting tasks of raising money, making films, and getting them

shown, with a clarity of vision and determination rarely achieved by those working in more popular arenas. Considering that most distributors would shy away from her chosen subject-matter, Mackenzie's successes were great indeed.'

from the obituary by Laurie Lewis, *The Independent*, 2004

Theatre

The Actresses' Franchise League provided an inspiration to a new wave of feminist theatre companies in the 1970s. Sidewalk Theatre Company was the first to revive AFL plays like *How the Vote was Won* while Mrs Worthington's Daughters re-staged works including Margaret Wynne Nevinson's *In the Workhouse* and J.M.Barrie's *The Twelve Pound Look*.

More recently contemporary playwrights have created new works in response to the theme like Rebecca Lenkiewicz's *Her Naked Skin* at the National Theatre or New Strides' *Tea with Mrs Pankhurst*. Lenkiewicz's play excited debate in *The Guardian* newspaper with a lively exchange over whether it depicted the suffrage movement accurately and whether its central lesbian relationship between a working class activist and a woman of the upper middle class illuminated the movement or was 'an unbelievable upstairs-downstairs romance'. The controversy showed how provocative the subject matter of the suffrage movement and its representation in the theatre remain even today:

In the Workhouse by Margaret Wynne Nevinson. Produced by Mrs Worthington's Daughters, 1980; image courtesy of photographer, Lesley McIntyre.

'"Surely the suffragettes deserve better than this?" They certainly did not deserve to be used as an opportunist vehicle on which to load all manner of modern baggage. I left the theatre annoyed that

the suffrage movement should have been travestied in this way. Incidentally, I would welcome an explanation of the play's title. I could find no reason for it, other than its titillating appeal'.

<div align="right">Elizabeth Crawford</div>

'Politics is stuffed into every corner of the epic staging and delicate dialogue, and I glimpsed Emmeline Pethwick Lawrence, Charlotte Despard, indeed generations of devoted suffragists, in Susan Engel's portrait of the single-minded Florence, while Celia had something of the glamour and emotional instability of the Pankhursts. This play was not always comfortable to watch. The nerve of sexual difference is the forcing ground of feminism, and Lenkiewicz made that nerve the political truth of her play.'

<div align="right">Sally Alexander</div>

Art

Ann Dingsdale and the 1866 Women's Suffrage Petition

In a feminine and arts and crafts tradition, textile artist Ann Dingsdale was inspired to create in 2002, a gentle wall hanging in fugitive, feminine colours. The hanging commemorates the 1866 Women's Suffrage Petition presented to an all-male Parliament by John Stuart Mill.

Ann Dingsdale creates her unique textiles from a kaleidoscope of source material; photo Pat Colman.

The fact that their hopes were greeted with derision spurred the women on to greater efforts to achieve equality on behalf of women in the future, if impossible in their own lifetimes.

The textile's fragile texture reminds us how tenuous is our knowledge of the lives of those first 1,499 women who signed for suffrage. They signed at a time when it was dangerous to deviate from the assigned domestic role. Risking one's

name and whereabouts becoming public knowledge in connection with a cause to which the established order was violently opposed, took courage and strength of character. Characteristically, no doubt women were prepared to risk all if it meant the chance of a better life for their daughters.

'I am a working woman,
My voting half is dead.
I hold a house and want to know
Why I can't vote instead?'

Sarah Ann Jackson 1866

History Recorded in the Subversive Stitch

'The petition humbly requests that Parliament should consider the expediency of providing for the representation of all householders, without distinction of sex.' The introductory words are machine embroidered into the top of the devoré satin and hand-made felt hanging.

Over many years, Ann has extensively researched the 1866 petition and the women who signed it. Beneath the introductory words, Ann has machine-embroidered all 1,499 names. Where a portrait has been available she has photographically imprinted it on the fabric so that faces peer out from the ghostly past.

Four Generations

Ann and others who have traced descendants of the early 20th century feminists, find the modern counterparts often have inherited something of the spirit that changed the world. For example among the signatures on the petition is that of Mrs Emily Evans Bell (c.1839-1893).

Emily, a classical actress and singer, signed the petition in the interval between her marriage in January 1866 and embarking on a honeymoon grand tour of Europe the following October. She may have delayed her departure in order to help gather signatures. It's equally likely that her husband, Major Thomas Evans Bell, an authority on Indian affairs, might have been held up in London by Parliamentary business. Both

husband and wife were members of the Central Committee of the National Society for Women's Suffrage.

Emily taught drama at a private school at West Heath. A pupil, Violet Markham, later wrote in her autobiography *Return Passage* p42:

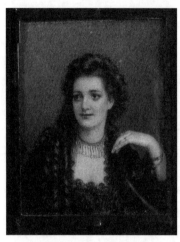

Miniature portrait of Emily Evans Bell by Edith Hinchley; courtesy of Emily's great, great-niece V. Irene Cockroft; photo David Cockroft.

'One remarkable woman crossed my path at West Heath, a certain Mrs Fairfax (stage name adopted by Emily Evans Bell) who ... taught us elocution. Mrs Fairfax was the first great artist to stir my imagination. There are passages in English poetry and literature in which for me her voice still echoes ... it is thanks to Mrs Fairfax that I ever became a speaker.'

Emily's daughter Ernestine Mills was an artist in the women's Cause who specialised in the unusual medium of enamel on metal. Her husband Dr Herbert Henry Mills, a staunch advocate of affordable health care for the poor, served on the Advisory Committee when the National Health Insurance Act was introduced in 1911.

Emily's grand-daughter Hermia Mills (1902-1987) qualified as a doctor and during her career served as medical officer at Holloway Prison. Hermia passed on information about her mother's volatile life to Emily's great, great-niece V. Irene Cockroft who writes about suffrage and art history.

13. ~ 1832-1928: THREE GENERATIONS OF WOMEN DEDICATE THEIR LIVES TO WINNING EQUALITY ~

1832

~ First Parliamentary Reform Act. More sections of men granted the vote. Women excluded.

1851

~ The National Census reveals a surplus of around half a million females of marriageable age. The 'spinster problem' is not helped by society's refusal to accept middle-class women in the workforce.

1855

~ The influential Society of Female Artists is founded. Later renamed the Society of Women Artists, its annual exhibitions continue to the present day.

1860

~ By signing only her initials on drawings submitted for the Royal Academy school's entrance exam, Laura Herford becomes the first female to be accepted as an art student there.

1866

~ Women's Suffrage Petition initiated by The Kensington Society is signed by 1,499 women.

1867

~ Second Parliamentary Reform Act widens franchise for men. An amendment to include women is defeated by 123 votes.

1870

~ Married Women's Property Act passed. A married woman gains the right to keep her own earnings and to inherit property.

1871

~ The progressive, unisex Slade School of Art opens its doors to both male and female students for the teaching of fine art. Many future suffrage campaigners train here. The 'spinster problem' grows.

1884

~ Third Parliamentary Reform Act enfranchises more men. Women still excluded.

1888

~ 'Arts and Crafts' accepted as a term describing a developing art movement. Whilst the Art Workers' Guild excluded women, the new Arts and Crafts Exhibition Society accepts their work.

1893

~ Female students at the Royal Academy are permitted to draw from the nude male model for the first time.

1897

~ National Union of Women's Suffrage Societies (NUWSS) formed under leadership of Millicent Fawcett.

~ Technological developments in paper production, printing and photography begin to transform the media. Newspapers seek photos that can be sensationalised to increase circulation.

1903

~ Women's Social & Political Union (WSPU) formed by Emmeline Pankhurst with slogan 'Deeds not Words'.

~ Sylvia Pankhurst wins scholarship for the Royal College of Art.

1906

~ The Bill for Women's Suffrage is talked out of Parliament.

~ WSPU members react with militant acts.

~ The *Daily Mail* newspaper describes the militants as 'suffragettes' as a derogatory term and to distinguish them in print from law-abiding suffragists. The term is accepted with pride by WSPU.

~ The Women's Press is founded.

1907

~ Artists' Suffrage League founded by professional women artists to assist preparations for first large-scale public suffrage demonstration. Around 3,000 NUWSS members march on Parliament to express solidarity in demanding Votes for Women. The march attracts widespread press coverage and the title 'Mud March' due to atrocious weather conditions.

~ The Women's Guild of Art is founded with May Morris as president.

~ WSPU holds first Women's Parliament at Caxton Hall.

~ WSPU split over tactics. Charlotte Despard forms break-away Women's Freedom League. WFL militancy takes the form of passive resistance.

~ WSPU *Votes for Women* newspaper founded by Emmeline and Frederick Pethick-Lawrence as joint editors.

1908

~ Henry Asquith, Liberal opposed to women's suffrage, becomes PM.

~ National League for Opposing Women's Suffrage formed.

~ Suffragettes attempt to rush the House of Commons. Many arrested.

~ Major suffrage processions are held in London.

~ Actresses' Franchise League founded.

~ Women's Freedom League member Cicely Hamilton achieves acclaim for her play *Diana of Dobson*'s starring Lena Ashwell at Kingsway Theatre. Hamilton's *Anti-Suffrage Waxworks* satire on anti-suffrage types goes on tour. With Bessie Hatton she founds the Women Writers' Suffrage League.

1909

~ Women's Exhibition held at Princes' Skating Rink, Knightsbridge for which Sylvia Pankhurst designs mural decoration and at which the *Waxworks* is staged.

~ A futuristic comedy by Cicely Hamilton and Chris St John, *How the Vote was Won*, is staged at the Royalty Theatre. A great success, the play is revived at numerous provincial suffrage events.

~ 108 members of the WSPU arrested for breaking windows of government offices. Their claim to political prisoner status is denied.

~ Hunger strikes begin, followed by forcible feeding.

~ Actresses' Franchise League stages Hamilton's *A Pageant of Great Women* at Scala Theatre after which it is restaged by numerous local groups.

~ NUWSS journal *The Common Cause* founded.

~ The Suffrage Atelier is formed, further to assist the suffrage campaign with making banners, posters and postcards.

1910

~ Government agrees to draw up a Conciliation Bill for votes for women.

~ The WSPU suspends militant activities.

~ PM Asquith suspends Parliament before the Bill can be passed.

~ Furious suffragettes march to the House of Commons. Police use brute force to disperse them and a riot breaks out in which many women are assaulted and injured. 18th November becomes known as 'Black Friday'.

~ General Election. Asquith returned to power.

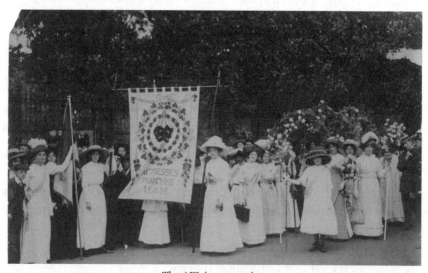

The AFL in procession;
image courtesy of the Museum of London.

1911

~ Many suffragettes boycott the National Census: 'No persons here, only women'.

~ Around 60,000 women carrying over 1,000 banners take part in the Women's Coronation Procession which stretches for seven miles.

~ Cicely Hamilton writes words for music composed by Ethel Smyth, *March of the Women*.

~ Second Conciliation Bill fails to be passed by Parliament.

1912

~ WSPU renews militant campaign with window smashing and arson.

~ Labour Party forms alliance with NUWSS.

~ Police raid WSPU headquarters, arrest Emmeline and Frederick Pethick-Lawrence.

~ Christabel Pankhurst flees to Paris.

~ Sylvia Pankhurst's socialism takes the suffrage campaign to London's impoverished East End.

~ Pethick-Lawrences protest against increasing violence and are expelled from WSPU. Continue to publish *Votes for Women*. WSPU starts a more outspoken newspaper, *The Suffragette*.

1913

~ Temporary Discharge of Prisoners (Cat & Mouse) Act is passed. Hunger striking suffragettes are released only to be re-arrested when health returns.

~ In protest, Emily Wilding Davison attempts to halt the King's horse running in the Derby, is kicked by hooves and dies of her injuries. WSPU holds solemn funeral procession.

~ NUWSS holds pilgrimage to distinguish its campaigning for the vote by peaceable means. Women from all over Britain march to London.

1914

~ Sylvia Pankhurst expelled from WSPU over East End socialist activities and consolidates the East London Federation of Suffragettes (ELFS).

~ 'Slasher' Mary Richardson attacks the *Rokeby Venus* painting at the National Gallery in protest at the way in which men idolise a painting (property) whilst denigrating real women. She is sentenced to eighteen months in prison with hard labour.

~ Outbreak of WWI. Most suffrage activities cease apart from those of women who, like Sylvia Pankhurst, oppose the war on socialist or pacifist grounds. Suffrage prisoners released.

~ Women support the government in War Effort. Many suffrage campaigners give active service in war zones as nurses or as theatre groups entertaining the troops.

~ Nina Boyle founds the Women's Police Volunteers to take the place of men called for military service. Headed by Margaret Damer Dawson and Mary Allen, the volunteers are renamed the Women's Police Service.

1918

~ Peace is declared. Representation of the People Act passed.

~ Women over thirty who meet property or education criteria, allowed to vote.

~ Women are entitled to stand for Parliament. Countess Markiewicz is elected for Sinn Fein. Refuses oath of allegiance and is disbarred.

1919

~ The Sex Disqualification Removal Act opens all the professions except the Church to women. Lady Astor becomes the first woman Member of Parliament.

1920

~ Oxford University admits women to degrees.

1922

~ Annie Swynnerton, painter and suffrage campaigner, is elected Associate of the Royal Academy, the first woman to be admitted since founder members Angelica Kauffman and Mary Moser in 1768.

1928

~ The Representation of the People Act gives the vote to all women over the age of twenty-one, on an equal basis with men.

THE VOTE.
July 4, 1913.
ONE PENNY.

"THE REAL DEVIL."

THE VOTE

THE ORGAN OF THE WOMEN'S FREEDOM LEAGUE.

Vol. VIII. No. 193. *Registered at the General Post Office as a Newspaper.* Friday, July 4, 1913.

Edited by C. DESPARD.

OBJECTS: To secure for Women the Parliamentary vote as it is or may be granted to men; to use the power thus obtained to establish equality of rights and opportunities between the sexes, and to promote the social and industrial well-being of the community.

COUNTRIES WHERE WOMEN VOTE:

AUSTRALIA.	UNITED STATES OF AMERICA	
NEW ZEALAND.	WYOMING	1869
	COLORADO	1893
TASMANIA.	UTAH	1896
	IDAHO	1896
	WASHINGTON	1911
	CALIFORNIA	1911
FINLAND.	OREGON	1912
	KANSAS	1912
	ARIZONA	1912
NORWAY.	ALASKA	1913
	ILLINOIS	1913

25

Nations—of Europe, Asia, Africa, and America—were represented by 2,000 Delegates at The International Woman Suffrage Alliance Congress, Budapest, June, 1913.

Votes for Women cover 13th June 1913;
image courtesy of Theatrewords.

14. ~ THE LONG CENTURY OF CATCHING-UP FOR WOMEN WORLDWIDE ~

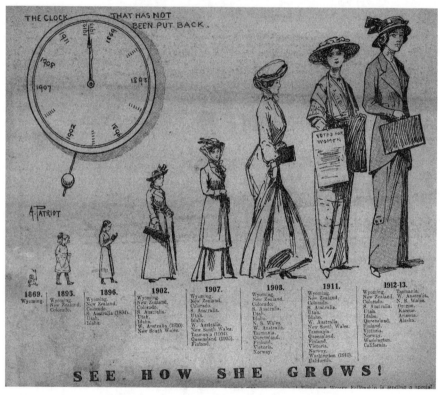

'See How She Grows!' Artist A Patriot (Alfred Pearse);
from the cover of *Votes for Women* 13th June 1913.

Vote granted (often gradualist, not universal suffrage and not every country is represented here):

1869	first state, Wyoming, USA
1881	Isle of Man
1893	first country, New Zealand
1902	Commonwealth of Australia
1906	first country to grant vote and the right to stand for election, Finland
1913	Norway
1915	Denmark, Iceland
1917	Russia
1917-60	Canada
1918	Austria, Germany, Poland, Luxembourg, Czechoslovakia
1918-28	United Kingdom
1919	Netherlands
1919-21	Sweden
1869-1920	United States of America
1929	Ceylon/Sri Lanka
1930	South Africa, Turkey
1931-75	Portugal
1931	Spain
1932	Brazil
1935-1950	India
1945	France, Hungary, Italy, Japan,
1946	Romania, Venezuela Yugoslavia
1947	Argentina, Bulgaria, Malta, China
1948	Israel, Belgium
1952	Greece, Mexico
1954	Colombia
1955	Ethiopia, Peru
1971	Switzerland

15. ~ COLLECTION OF SUFFRAGE ANTHEMS ~

1. *Shoulder to Shoulder*
(Tune: *Men of Harlech*)

From the daughters of the nation
Bursts a cry of indignation
Breathes a sigh of consecration
In a sacred cause.
They who share their country's burden
Win no rights, receive no guerdon,
Only bear the heavy burden
Of unrighteous laws.

Women young and older
Shoulder put to shoulder
In the might of sacred right
Bolder still and bolder.
Let no ancient custom bind you
Let one bond of suffering bind you
Leave unrighteous laws behind you,
Soon you shall be free!

2. *The Women's Battle Song*
(Tune: *Onward Christian Soldiers*. Words: Theodora Mills)

Forward sister women!
Onward ever more,
Bondage is behind you,
Freedom is before.

Raise the standard boldly,
In the morning sun;
'Gainst a great injustice,
See the fight begun!
Forward, forward sisters!
Onward ever more!
Bondage is behind you,
Freedom is before.

3. *The March of the Women*
(Music: Ethel Smyth. Words: Cicely Hamilton)

Shout, shout, up with your song!
Cry with the wind for the dawn is breaking.
March, march, swing you along,
Wide blows our banner and hope is waking.
Song with its story, dreams with their glory,
Lo! They call and glad is their word.
Forward! Hark how it swells
Thunder of freedom, the voice of the Lord.

Long, long, we in the past,
Cower'd in dread from the light of Heaven;
Strong, strong, stand we at last;
Fearless in faith and with sight new given.
Strength with its beauty, life with its duty
(Hear the voice, oh, hear and obey).
These, these beckon us on,
Open your eyes to the blaze of day!

Comrades, ye who have dared,
First in the battle to strive and sorrow;
Scorned, spurned, naught ye have cared,
Raising your eyes to a wider morrow,
Ways that are weary, days that are dreary,
Toil and pain by faith ye have borne.
Hail, hail, victors ye stand,

Wearing the wreath that the brave have worn!

Life, strife, these two are one!
Naught can ye win but by faith and daring;
On, on that ye have done,
But for the work of today preparing.
Firm in reliance, laugh a defiance
(Laugh in hope for sure is the end)
March, march, many as one,
Shoulder to shoulder and friend to friend!

4. *Rise Up Women!*
(Tune: *John Brown's Body*. Words: Theodora Mills)

Rise up, women, for the fight is hard and long;
Rise up in thousands singing loud a battle song.
Right is might, and in strength we shall be strong
And the cause goes marching on
Glory, glory, hallelujah! Glory, glory, hallelujah!
Glory, glory, hallelujah! The cause goes marching on.

We stormed the House of Commons with our little band so true
And we frightened all the Statesmen so they tremble through and through.
They clapped us into prison and we gladly went for you
And the cause goes marching on.
Glory, glory, hallelujah! Glory, glory, hallelujah!
Glory, glory, hallelujah! But the cause goes marching on.

5. *The Women's Marseillaise*
(Words: Miss F.E.M. Macaulay)

Arise! ye daughters of a land
That vaunts its liberty!
May restless rulers understand
That women must be free
That women will be free.

Hark! hark! the trumpet's calling!
Who'd be a laggard in the fight?
With vict'ry even now in sight
And stubborn foemen backward falling.
To Freedom's cause till death
We swear our fealty.
March on! March on! Face to the dawn
The dawn of liberty.
March on! March on! Face to the dawn
The dawn of liberty.

Arise! Tho' pain or loss betide
Grudge naught of freedom's toll.
For what they loved the martyrs died;
Are we of meaner soul?
Are we of meaner soul?
Our comrades greatly daring.
Thro' prison bars have led the way:
Who would not follow to the fray,
Their glorious struggle proudly sharing?
To Freedom's cause till death
We swear our fealty.
March on! March on! Face to the dawn
The dawn of liberty.
March on! March on! Face to the dawn
The dawn of liberty.

6. *Laggard Dawn*
(Allegedly based on a melody by the late Prince Edmond de Polignac,
arranged by Ethel Smyth. It is unclear who wrote the words.)

When will the weary night be over?
When will the laggard sun arise?
Behold the east aglow at his coming,
And soon will his radiance blind our eyes.

In fear we waited, in hope we shall meet him.

He bursts through the clouds! Up, up and greet him.
Long was the grieving, black the darkness.
Heavy the night;
For this the day shall fill you with gladness.
For this shall you sing in your delight.

What though we suffered and wept in our sorrow.
'Tis gone with the night, we hail the morrow!
Sisters, the poor and friendless need you,
Seek you where other help has failed;
Your faithful hands shall steer through the tempest,
To wide sunlit oceans yet unsailed.

Bring balm and healing to hearts that are breaking,
And point to the sky where hope is waking.
What of the friends who fought beside us,
Gone from us never to return?
Beyond the stars their bright spirits watch us,
And lend us the fire wherewith we burn.

They bore our burden,
They help us to bear it.
And Victory won
Will know and share it!
Lost to our vision yet are they here,
Whispering softly, softly,
Lo dawn is near, dawn is near.

7. *The Purple, White and Green*
(From *Votes for Women* 14th May 1909, p.659, unattributed. Tune: *The Wearing of the Green*)

Och! Sylvia, dear, an' did yez hear the news that's goin' roun'?
The wimmen are by law forbid to tread St. Stephen's ground!
The Franchise we're not goin' to get, our colours can't be seen;
They'll be hangin' wimmen next for wearin' Purple, White, and Green!
I met wid Mrs Lawrence, an' she tuk me by the han';

Says she, "How's Women's Suffrage, an' how does it stan'?"
'Tis the most distressful subject that iver yet was heard:
They're sending us to Holloway for mentioning the word!

Then if the prison uniform's the badge we all must wear,
'Twill sarve to 'mind us that 'twas men – mere men – that sint us there.
So pluck the button from your breast an' fling it on the sod,
And niver fear 'twill multiply, tho' underfoot 'tis trod.
When God forbids the blades of grass from growin' as they grow,
And when the flowers in summer-time their colours dare not show,
Och! It's then I'll change the colours that I wear in my caubeen,
But till that day, please God, I'll stick to Purple, White, and Green!

8. *Blue-Bell*

(Published by Wimbledon WSPU December 1908. Words: suffrage
supporter Frank Bather of Wimbledon. Tune: *The Blue Bells of
Scotland*. Blue-Bell was the nick-name for a well-loved, prominent
suffragette with a Scottish background: Flora Drummond.)

Oh! where, and oh! Where has your Hieland lassie gone?
Oh! where, and oh! Where has your Hieland lassie gone?
She's hecklin' Cabinet Meenisters till Woman's got her own;
And it's oh! In our hearts, but we wish her safe at home.

Oh! where, and oh! Where does your Hieland lassie dwell?
Oh! where, and oh! Where does your Hieland lassie dwell?
She's kept in Castle Holloway, in a dim and airless cell;
And it's oh! In our hearts, but we wish our lassie well.
Oh! what, and oh! what does your Hieland lassie wear?
Oh! what, and oh! what does your Hieland lassie wear?
A second class prisoner's mob-cap all round her bonny hair
And it's oh! In our hearts, but we love our lassie sair.

Suppose, and suppose, they should set your lassie free.
Suppose, and suppose, they should set your lassie free.
She'd speak and fight to conquer, for her sisters, liberty.
And it's UP with our hearts! We will win or we will dee.

9. *Christabel*

(Tune: *Tramp! Tramp! Tramp!* Courtesy of the John Innes Society of Merton Park. Published by Wimbledon WSPU December 1908. Words by Frank Bather.)

In the prison where I sit,
Thinking, sisters dear, of you,
Hark! A note of triumph rises far away.
For the gloom of night may fall,
But I hear our army call
That our victory is dawning with the day.

Work! Work! Work! The vote is coming!
Cheer up, girls! The day's at hand
When, for all their chaff and knocks,
We shall get the Ballot-box
And a vote for the leaders of our land.

Men may drag us through the mire
By the ruthless hands they hire;
They may cage our bodies here behind the walls,
But our hearts are there outside,
For the spirit ranges wide,
And it pierces where the voice of freedom calls.

Fight! Fight! Fight! The vote is coming!
(Repeat chorus)

Do they bar us from our House
With police ten thousand strong?
They will hide their head and stop their ears in vain:
Thro' the land there swells a crowd,
Like a storm-wind, roaring loud –
'Let the women take their olden right again.'

Shout! Shout! Shout! The vote is coming!
Cheer up, girls, the day's at hand
When, for all their chaff and knocks,

We shall get the Ballot-box
And a vote for the leaders of our land.

Later Anthems

10. *The Women's Anthem: Celebrating a Centenary of Female Suffrage in Victoria, Australia.*
Gifted to Women 28th November 2008. Lyrics and music © Kavisha Mazzella/Peer Music; commissioned by the Victorian Women's Trust 2008 by whose courtesy these words are reproduced.

The moon is hidden in the clouds
The fire light is dying
In the dark slum and street
Men, women, children crying
No work today means no pay
And no pay means we're starving
Mother I'm with child again
I feel like I am dying.

A pen, a pen your weapon be
My fine courageous women
Let's sign our names a thousand times
For freedom that's hard winning
No more let fear and anger rule
With heavy hand of violence
The moon is shining in the sky
As we break the silence.

Chorus

Love and Justice be my flag
I'll live my truth what e're will be
I swear that I cannot rest
'til there's equality.
Love and Justice be my flag
I'll live my truth whatever comes

So many rivers to cross
'till our journey's done.

All who toil the weary Earth
See beyond your measure
Women are real gold
For all of us to treasure.
For every heroine that's named
There are a thousand nameless
Who live to make a better day
With acts of love and justice.

Chorus

Daughter, sister, mother, wife
When you rise so shall others
Happiness will fall upon
Son, father, husband, brother.
In house and in the marketplace,
Town and countryside
Let our laughter spread its wealth
It's surely our birthright!

Chorus

Oh! I had the strangest dream
It came one starry midnight
That men and women all joined hands
In peace and loving friendship.
All broken hearts were mended
All broken bodies healed ...
River, mountain, rocks rejoiced
The Bells of Freedom pealed!

Chorus

~ BIBLIOGRAPHY ~

General

A.J. R, ed.: *The Suffrage Women's Annual* and *Women's Who's Who*, Stanley Paul, 1913

Atkinson, Diane: *The Suffragettes in Pictures*, Sutton Publishing/ Museum of London, 1996

Atkinson, Diane: *The Purple, White & Green; Suffragettes in London 1906-14*, Museum of London, 1992

Banks, Olive ed: *The Biographical Dictionary of British Feminists* Vol. One, Harvester/Wheatsheaf, 1985

Blackburn, Helen: *Record of Women's Suffrage*, Williams & Norgate, London, 1902

Brittain, Vera: *Testament of Youth*, Fontana, 1979 and other editions

Bush, Julia: *Women Against the Vote: Female Anti-Suffragism in Britain*, Oxford University Press, 2007

Crawford, Elizabeth: *The Women's Suffrage Movement in Britain and Ireland, a Regional Survey*, Routledge, 2006

Crawford, Elizabeth: *Enterprising Women: the Garretts and their circle*, Frances Boutle, 2002

Crawford, Elizabeth: *The Women's Suffrage Movement, A Reference Guide 1866-1928*, UCL Press, 1999

Dingsdale, Ann: *Growing Up For Suffrage, Resource Pack Women's History Key Stages 1 & 2*; produced by the Fawcett Library at London Guildhall University, 1997 (now The Women's Library, London Metropolitan University)

Gardiner, Juliet: *The New Woman*, Collins and Brown, 1993

Goodman, Judy; Tudor Jones and John Wallace: *Dorset Hall 1906-1935 A House, A Family, A Cause: Votes for Women!*, The John Innes Society of Merton Park, 1994.

Hamilton, Cicely: *Marriage as Trade*, The Women's Press, 1981

Hamilton, Cicely: *Life Errant*, Dent, 1935

Heath, Gerald and Joan: *The Women's Suffrage Movement in and around Richmond and Twickenham*, Borough of Twickenham Local History Society, 1968, reprinted with revisions, 2003

Holder, Jean and Katherine Milcoy: *Dare To Be Free! Resource Pack Women's History Key Stage 3*; produced by the Fawcett Library at London Guildhall University, 1997 (now The Women's Library, London Metropolitan University)

Liddington, Jill: *Rebel Girls: their fight for the vote*, Virago Press, 2006

Liddington, Jill and Jill Norris: *One Hand Tied Behind Us: the Rise of the Women's Suffrage Movement*, Virago Press, 1978

Markham, Violet: *Return Passage*, Oxford University Press, 1953

Marlow, Joyce: *Votes for Women: The Virago Book of Suffragettes*, Virago Press

Mulvihill, Margaret: *Charlotte Despard*, Pandora Press, 1989

Pankhurst, Sylvia: *The Suffragette Movement*, Virago Press, 1977

Parker, Sarah E.: *Grace and Favour; The Hampton Court Palace Community 1750-1950*, Historic Royal Palaces 2005

Purvis, June: *Emmeline Pankhurst, a Biography*, Routledge, 2002

Raverat, Gwen: *Period Piece: a Cambridge Childhood*, Faber and Faber, 1952

Robinson, Jane: *Bluestockings: the Remarkable Story of the First Women to Fight for an Education*, Viking, 2009

Art

Anscombe, Isabelle and Charlotte Gere: *Arts & Crafts*, Academy Editions, London, 1978

Atkinson, Diane: *Funny Girls: Cartooning for Equality*, Penguin, 1997

Atterbury, Paul and Louise Irvine: *The Doulton Story*, Royal Doulton Tableware Ltd, 1979

Burkhauser, Jude, ed.: *Glasgow Girls – women in art and design 1880-1920*, Canongate, 1990

Callen, Andrea: *Angel in the Studio: Women in the Arts & Crafts Movement 1870-1914*; Astragal, 1979

Cherry, Deborah: *Painting Women: Victorian Women Artists*, Routledge, 1993

Cockroft, V. Irene: *New Dawn Women: Women in the Arts and Crafts and Suffrage Movements at the Dawn of the 20th Century*, Watts Gallery, 2005

Cumming, Elizabeth: *Phoebe Anna Traquair 1852-1936*, National Galleries of Scotland in association with the National Museums of Scotland, 2005.

Cumming, Elizabeth and Wendy Kaplan: *The Arts and Crafts Movement*, Thames & Hudson, 1991

Foster, Alicia: *Tate Women Artists*, Tate Publishing, 2004

Gould, Veronica Franklin: *Mary Seton Watts (1849-1938) Unsung Heroine of the Art Nouveau*, Watts Gallery, 1998

Gould, Veronica Franklin: *Watts Chapel*, The Watts Gallery, c.1990

Hirsch, Pam: *Barbara Leigh Smith Bodichon, Feminist, Artist and Rebel*, Chatto & Windus, 1998

Lomax, Abraham: *Royal Lancastrian Pottery 1990-1938*, Abraham Lomax, 1957

Marsh, Jan and Nunn: *Pamela Gerrish, Pre-Raphaelite Women Artists*, Manchester City Art Galleries, 1997

Pankhurst, Richard: *Sylvia Pankhurst, Artist and Crusader*, Paddington Press Ltd, 1979

Tickner, Lisa: *The Spectacle of Women, Imagery of the Suffrage Campaign 1907-14*, Chatto & Windus, 1987

Theatre

Ablard, Eleanor ed.: *Edy: Recollections of Edith Craig*, Frederick Muller, 1949

Ashwell, Lena: *Myself a Player*, Michael Joseph Ltd, 1936

Cockin, Katharine: *Edith Craig (1869-1947) Dramatic Lives*, Cassell, 1998

Cockin, Katharine: *Women and Theatre in the Age of Suffrage, The Pioneer Players 1911-1925*, Palgrave, 2001

Cockin, Katharine ed.: *The Collected Letters of Ellen Terry vols 1 and 2*, Pickering, 2010 and further volumes forthcoming

Croft, Susan: *...She Also Wrote Plays: an International Guide to Women Playwrights from the 10th to the 21st Century*, Faber and Faber, 2001

Gandolfi, Roberta: *La Prima Regista: Edith Craig, fra rivoluzione della scena e cultura delle donne*, Roma: Bulzoni Editore, 2003

Gardner, Viv and Susan Rutherford: *The New Woman and Her Sisters: Feminism and Theatre 1850-1914*, Harvester Wheatsheaf, 1992

Gates, Joanne E.: *Elizabeth Robins 1862-1952; Actress, Novelist and Feminist*, University of Alabama Press, 1994

Gooddie, Sheila: *Annie Horniman: a Pioneer in the Theatre*, Methuen Drama, 1990

Greer, Mary K.: *Women of the Golden Dawn: Rebels and Priestesses*, Park St Press, 1995

Holledge, Julie: *Innocent Flowers: Women in the Edwardian Theatre*, Virago, 1981

Holroyd, Michael: *A Strange Eventful History: the dramatic lives of Ellen Terry, Henry Irving and their Remarkable Families*, Vintage, 2009

John, Angela V.: *Elizabeth Robins: Staging a Life 1862-1952*, Routledge, 1995

McCarthy, Lillah: *Myself and My Friends*, Butterworth, 1934

Melville, Joy: *Ellen and Edy: a Biography of Ellen Terry and her daughter*, Edith Craig 1847-1947, Pandora Press, 1987

Moore, Eva: *Exits and Entrances*, Chapman & Hall ltd, 1923

Pfisterer, Susan: *Australian Suffrage Theatre*, unpublished Doctoral Dissertation,University of New England, 1995 (on Inez Bensusan)

Pogson, Rex: *Miss Horniman and the Gaiety Theatre*, Manchester, Rockliff, 1952

Robins, Elizabeth: *Both Sides of the Curtain: an Autobiography*, William Heinemann, 1940

Smyth, Ethel: *A Final Burning of Boats*, Longman's, 1928

Stowell, Sheila: *A Stage of their Own: feminist playwrights in the suffrage era*, Manchester University Press, 1991

Whitelaw, Lis: *The Life and Rebellious Times of Cicely Hamilton*, The Women's Press, 1990

Selected Plays (mentioned in this book or in the exhibition)

Baker, Elizabeth: *Chains* in Fitzsimmons and Gardner

Bell, Florence and Elizabeth Robins: *Alan's Wife* in Fitzsimmons and Gardner

Bennett, P.R: Mary Edwards *An Anachronism* in Gardner

Bensusan, Inez: *The Apple* in Croft, 2009

Chapin, Alice: *At the Gates* in Croft, 2009

Croft, Susan: *Votes for Women and Other Plays*, Aurora Metro, 2009 (also plays by L.S.Phibbs and Helen Nightingale)

Fitzsimmons, Linda and Viv Gardner eds.: *New Woman Plays*, Methuen, 1991

Ford, Emily: *Rejected Addresses*, Esford, 1882

Ford, Emily: *Careers*, Joseph Dodson, 1883

Gardner, Viv: *Sketches from the Actresses' Franchise League*, Nottingham Drama Texts, 1985

Glover, Evelyn: *A Chat with Mrs Chicky* in Hayman and Spender

Glover, Evelyn: *Miss Appleyard's Awakening* in Hayman and Spender

Hamilton, Cicely: *A Pageant of Great Women* in Gardner

Hamilton, Cicely and Christopher St John: *How the Vote was Won* in Croft, 2009

Hamilton, Cicely and Christopher St John: *The Pot and the Kettle*, N.p, 1909

Hamilton, Cicely: *Diana of Dobson's,* in Fitzsimmons and Gardner

Hamilton, Cicely: *Jack and Jill and a Friend*, French, 1911

Harraden, Beatrice: *Lady Geraldine's Speech* in Gardner

Hatton, Bessie: *Before Sunrise* in Gardner

Hayman, Carole and Dale Spender: *How the Vote Was Won & Other Suffragette Plays*, Methuen 1984

Jennings, Gertrude: *A Woman's Influence* in Hayman and Spender and in Gardner

Lyttelton, Edith: *The Thumbscrew*, Longman's, 1912

Lyttelton, Edith: *Warp and Woof,* T. Fisher Unwin, 1908

Nevinson, Margaret Wynne: *In the Workhouse*, in Croft, 2009

Robins, Elizabeth: *Votes for Women* in Croft, 2009

St John, Christopher and Charles Thursby: *The Coronation,* The International Suffrage Shop, 1912

Tippett, Isabel: *The Stuff That 'Eroes Are Made Of* in *The Vote* 19th August 1911, p 207-9

Wentworth, Vera: *An Allegory* in Gardner

Elizabeth Wordsworth: *Poems and Plays,* Oxford University Press/ Humphrey Milford, 1931

Also see 'Chronology of Suffrage Plays 1907-1914' in *Votes for Women and Other Plays* ed. Susan Croft, Aurora Metro, 2009

Websites

http://www.suffragette.org.uk

http://www.ellenterryarchive.hull.ac.uk

http://www.bbc.co.uk/archive/suffragettes/8301.shtml?all=2&id=8301

http://www.ellenterrybarntheatre.co.uk/index.htm

VOTES FOR WOMEN
and other plays
ed. Susan Croft

The astonishing women involved in the Actresses' Franchise League set up their own theatre companies and engaged with the battle for the vote by writing and performing campaigning plays all over the country. They launched themselves onto the political stage with their satirical plays, sketches and monologues whilst at the same time challenging the staid conventions of the Edwardian Theatre of the day. The legacy of their inspiring work to change both theatre and society has survived in the political theatre, agit-prop and verbatim theatre we know today.

Including:

How the Vote was Won by Cicely Hamilton and Chris St. John

The Apple by Inez Bensusan

Jim's Leg by L.S. Phibbs

Votes for Women by Elizabeth Robins

At the Gates by Alice Chapin

In the Workhouse by Margaret Wynne Nevinson

A Change of Tenant by Helen Margaret Nightingale

Introduced and set in an historical context by Dr Susan Croft together with a chronology of suffrage drama.

ISBN 978-1-906582-01-2

£12.99

CLASSIC PLAYS
by women
from 1600 - 2000
ed. Susan Croft

A unique anthology of classic plays by female dramatists in the UK from 1600 – 2000, this collection brings together an extraordinary body of work with enduring appeal. Staged in theatres by successive generations and proving relevant to contemporary audiences, the plays demonstrate the wit, theatrical skill and innovation of their creators in exploring timeless topics from marriage, morality and money to class conflict, rage and sexual desire.

An essential resource for students, playwrights, colleges, universities and libraries, this collection also provides theatres with the opportunity to schedule a range of theatrical classics by women.

Includes:

Paphnutius by Hrotswitha (extract)

The Tragedy of Mariam by Elizabeth Cary (extract)

The Rover by Aphra Behn

A Bold Stroke for a Wife by Susanna Centlivre

De Monfort by Joanna Baillie

Rutherford and Son by Githa Sowerby

The Chalk Garden by Enid Bagnold

Top Girls by Caryl Churchill (extract)

Stones in his Pockets by Marie Jones

ISBN 978-1-906582-00-5

£16.99